Nine Designs
for
Inner Peace

P9-BID-876

Nine Designs
for
Inner Peace

The Ultimate Guide
to Meditating
with Color, Shape,
and Sound

SARAH TOMLINSON

Destiny Books
Rochester, Vermont

Destiny Books
One Park Street
Rochester, Vermont 05767
www.DestinyBooks.com

Destiny Books is a division of Inner Traditions International

Copyright © 2008 by Sarah Tomlinson
Foreword © 2008 by Robert Edwin Svoboda

All rights reserved. No part of this book may be reproduced or utilized in any form or by any means, electronic or mechanical, including photocopying, recording, or by any information storage and retrieval system, without permission in writing from the publisher.

Library of Congress Cataloging-in-Publication Data

Tomlinson, Sarah, 1968–
 Nine designs for inner peace : the ultimate guide to meditating with color, shape, and sound / Sarah Tomlinson.
 p. cm.
 Summary: "A complete guide to creating planetary Yantras to access their healing and centering benefits"—Provided by publisher.
 Includes bibliographical references and index.
 ISBN-13: 978-1-59477-194-1 (pbk.)
 ISBN-10: 1-59477-194-4 (pbk.)
 1. Yantras. 2. Meditation. I. Title. II. Title: 9 designs for inner peace.
 BL1236.76.Y36T66 2008
 294.5'37—dc22

 2007027554

Printed and bound in India by Replika Press Pvt Ltd.

10 9 8 7 6 5 4 3 2 1

Text design by Peri Champine and layout by Rachel Goldenberg
This book was typeset in Garamond Premium Pro with Linotype Didot as the display typeface.

Photographs by Lori Berkowitz Photo. Yantra outlines in the appendix prepared by Charles Cohen. Color Yantra scans by Ray Henders.

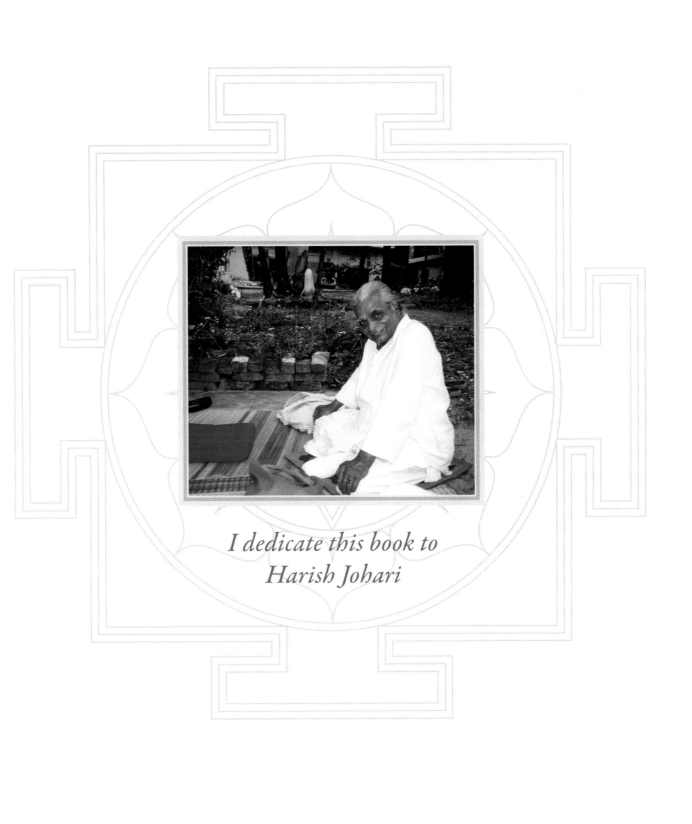

*I dedicate this book to
Harish Johari*

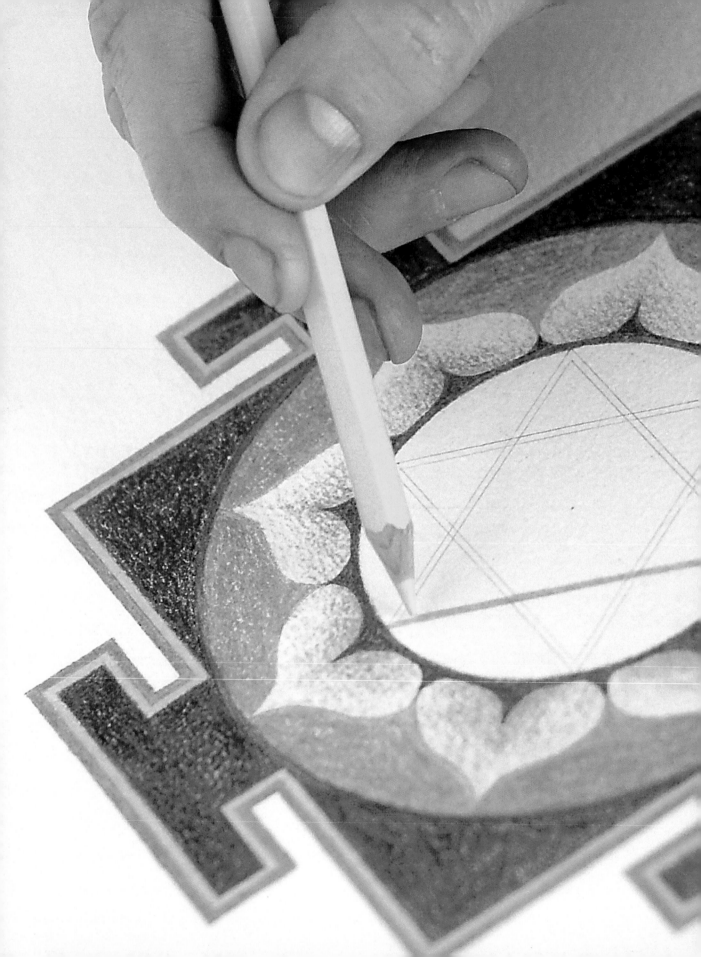

Contents

Foreword

Humans are creative animals. Since the dawn of self-awareness our species has made it a priority to remake external objects in imaginative ways for the express purpose of eliciting and enhancing selected states of being in our fellows who observe or wield those objects. Cave painters tens of thousands of years before us limned and pigmented images of their fellow creatures; their work continues to enrapture us today. Ensuing generations continued to hone their artistic skills until now, when in an apparent reaction against accurate depiction the postmodern "aesthetic" rejects both skill and "good taste." Much of what we are fed today is "junk art," which is about as satisfying and nourishing as "junk food." No wonder then that so many present-day lives are dry, tasteless, unsatisfying.

Students of ayurveda, India's ancient system of health and healing, are taught that "loss of taste" is a serious disease; they learn to treat it by using substances and actions to return "good taste" to both palate and psyche. Students of the Indian plastic arts similarly learn how to nourish the soul by imbuing their manufactures with "good taste." In classical Indian tradition "good taste" means good *rasa,* a concept that unifies within itself the body's liquid realities (including water, sap, lymph, and semen), the physical and aesthetic senses of taste, our personal emotions, and the sentiment prevailing within a work of art. Great art purifies our feelings, improves our tasting abilities at all levels, and satisfies our thirst for beauty and satisfaction.

True art nourishes us at an archetypal level that spills into our spiritual, mental, and physical realities; it renders our lives *rasatmaka,* filled to the brim with pure, refreshing fluids that trickle down to the subtlest core of our beingness. Those with "good taste" create tasty, nourishing art for others with "good taste" to dine on.

Creativity lies at the hub of the spiritual system known as *tantra,* a set of methodical practices that seeks to transform us from mundane into supramundane beings while preserving and enhancing our rasa. *Tantra* is the process of transmutation; *mantra* provides the metamorphic shakti (energy); *yantra* is the crucible in which that energy is collected. The yantra is the visible manifestation of the shakti in the mantra, the mantra the aural manifestation of the shakti in the yantra. Amalgamate these via a suitable process, and you have alchemy, which is known in India as *rasa vidya,* "the real knowledge of rasa."

India's seers fashioned thousands of different yantras, each designed to fabricate a particular "flavor" in reality. Be the purpose of the process spiritual or mundane, success at tantra is attained when the desired rasa is obtained. Traditionally only an advanced aspirant would be initiated into a particular yantra with its appropriate mantra; the initiating guru would then vigilantly supervise the procedure until success was achieved. As apprentice European painters during the Middle Ages would become seasoned artists by interning in a master's atelier, so greenhorn designers and makers in India would live with their gurus, sometimes for years, while being molded into experts at their crafts.

We are incalculably fortunate that yantras and mantras that were once closely guarded secrets are now available in print, and less than fortunate that authorities in these lores are now few and far between. Providence connected Sarah Tomlinson with one such authority, the late Harish Johari; during her time with him and his family she was privileged to receive the direct transmissions from him that have led to the book you now hold. When you follow with attention and dedication the instructions contained herein, it will be for you as if you too were the recipient of Harish Johari's keen attention.

Few humans are such consummate artists as to be possessed ceaselessly by the muse, but each time we yield to the primordial human urge to create we open ourselves to the muses, that they may live and act through us. Creativity showers blessings on us, on humankind, and on the cosmos, for the more we encourage creativity in ourselves, the more creative the universe itself becomes.

By tapping in to the very source of creativity, the tantric tradition renders creativity itself exponentially more creative. To draw or paint a yantra is creative; to revere the yantra thus produced, offering it your vitality in the form of your attention and

your life force *(prána),* you bring the yantra to life. If you nourish it, it will nourish you, for a well-done yantra quenches all manner of thirsts with its symmetry, energy, and vitality. Properly attended to, a yantra will project its harmony into the spaces of your life, drawing your awareness into the embrace of its primordial depths.

Even if you cannot now invest the substantial time and serious meditative application needed to achieve this degree of alignment with the yantra, every sincere attempt you make will bring you and your yantra closer. Even if you are not a "great" artist, a yantra is "great art," and the process of yantra creation will put you squarely on the road of becoming a great artist. Sarah Tomlinson has opened the door to yantra for you; I invite you to walk through that door, where juiciness awaits.

DR. ROBERT E. SVOBODA

Dr. Robert E. Svoboda, a 1980 graduate of Tilak Ayurveda Mahavidyalaya at the University of Pune, was the first Westerner ever to graduate from a college of ayurveda and be licensed to practice ayurveda in India. During and after his formal ayurvedic training he was tutored in ayurveda, yoga, jyotish, tantra, and other forms of classical Indian lore by his mentor, the Aghori Vimalananda. Dr. Svoboda travels the world lecturing, consulting, teaching, and writing and is the author of more than a dozen books, including *Ayurveda: Life, Health, and Longevity* and *AGHORA: At the Left Hand of God.*

Acknowledgments

The material at the heart of this book was given to me as a sacred teaching by Harish Johari. *Nine Designs for Inner Peace* arose out of my own insights into these teachings and from my desire to share with students a way to learn these steps even when I could not be with them in person. The time taken to create the book became a rich opportunity to share and experience this profound practice more deeply. Throughout the process my understanding has been immeasurably expanded by my peers and mentors.

Those who deserve special mention are Linda Cirino, for her devoted and articulate writing assistance, which helped me translate an idea into a literary work; my wonderful agent, Eva Talmadge, and the Emma Sweeney Agency for their conviction in this work; Mavis Gewant, Pieter Weltevrede, and Carmen Carrero for sharing with me much of the visual tradition of Harish's teachings; Seema Johari for continuing to enrich my knowledge of the Johari teachings; Dr. Robert E. Svoboda for his vast inner resources on the subject of tantra and for so generously writing the foreword to this book; Lori Berkowitz for her beautiful photography; Charles Cohen for his visual graphic dexterity; Ray Henders for the brilliant colored Yantra scans; Gavin, Liz, and Elyse Stewart for encouraging me to put this into book form; and my first agent, Andrea Pedolsky, who initially approached me with the idea of creating a Yantra workbook. Many thanks go to my publisher, Inner Traditions, and their dedication to Harish's teachings—to my editor, Jamaica Burns, for her incredible sensitivity with

editing and refining the manuscript, and to Jeanie Levitan, Peri Champine, Cyndi Ryan, and Rachel Goldenberg for weaving together the many elements of this book so beautifully. And, of course, I must thank my parents, Chris and Barbara Tomlinson, who continue to be a source of strength, support, and renewal.

The wisdom of Ancient Ayurveda and the teachings of Edward Tarabilda continue to make this a living, breathing practice, bringing the planetary archetypes to life so powerfully.

And most importantly, a thank-you to Gandharva who has been my light, love, and inspiration every step of the way.

Introduction to the Nine Designs

I was born in England, into an artistic family, in a creative atmosphere where painting, drawing, cooking, and music were constant themes. I can see the kitchen table spread with sheets of paper upon which I had created colorful arrays of potato prints. These were the impressions left by potatoes that we had cut in half and carved a design out of before soaking the surface in colored paints. At a later age the jewelry gift boxes made from embroidered designs I had sewn together kept me entertained. The emphasis on these projects was always the fun of the activity itself. The beautiful end results were usually given away as gifts, or became something useful such as pot holders. My mother had a Richard Hittleman Yoga record that I listened to from the age of fourteen, while studying the manual and practicing the postures. These creative and spiritual conditions were ripe for the practices that would later structure and become the core disciplines in my life. From this creative haven I embarked upon art school and then yoga school and finally I came to a crossroads. Now what? There was only so much "school" I could do, and the completion of an art exhibit or a physical yoga practice left me with only fleeting happiness. I wanted to integrate all that I had learned, but I was not yet sure how it was to be done.

Some people find their passion in motherhood, or in a fulfilling job—but I knew there was some way I was yet to discover that would weave together all the artistic and spiritual practices I enjoyed in a way that would create the fabric of a whole way of life.

The answer came almost as the question was raised. I saw the book *Tools for Tantra*, a book on the Goddess Yantras by Harish Johari, in a bookstore in Sedona, Arizona, where I happened to be vacationing with my parents. The process of Yantra painting Harish described appeared to me both mystical and beautiful. The explanations—both devotional, aspiring to worship certain deities, and scientific, what happens to each part of the brain as we coordinate thinking with doing and praying—completely captivated me. I started to draw the outlines for the Yantras and began to process what I was reading.

So began this path which has at the root of it the practice of creating Yantras, but which has since extended to encompass all that I do. The Yantras are now a starting point, a focus, a joy to make and share.

That same summer I returned home to New York to see that Harish Johari was by chance coming to New York State from India, for what would be one of his last few visits to the United States, to teach a Yantra painting workshop. I signed up immediately, and from there I was hooked.

I was a little terrified at first of this abrupt, elderly Indian gentleman, but the twinkle in his eyes and the deep peaceful state I felt as I sat beside him overrode the fear of his rather raging personality. Six months later I was on a plane to Delhi and then a bus to Haridwar, the town where Harish lived with his extended family and his students from Europe. During all the years of practicing hatha yoga I had never really felt the pull to go to India, but this time nothing could stop me. From day one, the four to six hours each morning I spent painting under his tutelage, along with the daily walks to the Ganges to bow down to Mother Nature and become absorbed in the devotional climate of this holy town, were but a morsel of the real fruits of the trip: the attention to the sacred in the everyday activities in his household.

From the cleaning of the house (a layer of dust seems to cover every surface there within twenty-four hours) and the washing and ironing, to the cooking and preparation of each meal, each activitiy was done as a beautiful *sadhana* (spiritual practice). The meal preparation, which took a large portion of the day, included great thought to the day of the week and the appropriate spices and styles of cooking. Preparing the ingredients included much cleaning and sorting through unprocessed products and soon I had my hands full picking leaves off the fresh herb plants that would season

the day's dish. On the first day Dada (as Harish was affectionately called by his close friends and family) said to me, "Now you are here you will really be part of the family and do as we all do." I felt loved and honored by this. In any other context I might have felt it to be demeaning, but here it was a gift. The greatest gift I received from him was to cultivate this attention in my daily life. There was no more rushing to do the vegetables so that I could go and meditate, no more rushing to finish one painting in order to start the next, all that mattered was the quality of attention to the thing I was doing at that moment and the immense amount of happiness and love I felt as a result.

Harish set the tone for his mindful approach to the activities of the day in a conscious way. The day started for him with hours of prayer and ritual and by the time his students and other members of the household surfaced we would sit with him outside as the fire began to die down; this morning practice held the flavor for the day, the ritual, active prayer and the silent devotion.

Harish was a supreme example of this attentive approach. He would paint on my painting to show me things, so focused and careful with his brushstrokes that the painting came to life with the devotion that those careful gestures contained. And the food he prepared—often he would make a special dish, usually a vegetable accompaniment to the main dish, which would always taste of something wonderful and out of the ordinary that I couldn't quite put a name to. It was inspiring to witness the quality of living that he had so beautifully mastered and which showed itself in so many ways. He had written many books on art, ayurveda, massage, and breathing. He had created sculptures and music and used astrology and gemology in his work. Each of the subjects that he taught was intended to lead a way back through conscious attention, to reveal how all actions are to nourish and honor that which is sacred in each moment.

Sometimes you have to journey to a far off place to see clearly what is right in front of you. My travels in India were a little like that. I can better appreciate the richness of my childhood, the creative projects that my mother never ceased to come up with and share and encourage me with—the sewing, cooking, printing, drawing, knitting, painting, and beyond. These early pastimes and the sense of community and family I enjoyed as a child came into much clearer focus from my travels. My life in the here and now is infused with this appreciation of both my childhood and my time spent in India.

Heightened awareness of the senses through my connection to sound, color, and shape allows me to taste the spirit in my everyday life. Today I went for a walk and was in awe at the range of blues in the sky as the swirls of clouds crossed above me, the shapes of the trees and the distinct leaves. The sounds of the wind blowing

in different directions amid other natural and man-made noises made me feel so alive. From these practices it is as if my sensual perceivers have been cleansed—I can actually see bright colors where before there was one muted color, enjoy distinct sounds where before I didn't notice them, and appreciate the range of shapes changing before my eyes. Much of what we see in nature is ephemeral, like the color of the sky; the ability to appreciate the richness of the moment has been a way for me to achieve immense joy and recognize the wonder of being.

I am deeply grateful for the time I spent in India with the Johari family. Harish would say that I learnt a lot whilst there "the painting and everything else. . . ." He knew I had gained new eyes to see with—and his stern words gradually melted into a softer more peaceful space between us. Harish was initially a temple sculptor and painter and I believe that this meditative training in the tantric arts led him to develop the other areas of study and expertise. It is my intention to share with you this powerful practice of creating Yantras to enhance your own experience of the sacred in the mundane, elevating your waking state of consciousness so that you are more peaceful and centered in all that you do.

Active Meditation

Think of an activity that you engage in that is fulfilling and so pleasurable and absorbing that it brings you into the present moment. By this I mean that it draws you out of the concerns, worries, and occupations that reside in the mind seemingly all of the time. You notice a lightness of spirit, a happiness that arises in an inexplicable way. Physically, you experience an unwinding of the nervous system; your body relaxes. Being fully engaged in a creative project leaves little room for extraneous mental activity—its very nature awakens dormant pleasure that resides within. The rhythm and repetitiveness of sewing, knitting, and calligraphy, for example, are soothing; they let the mind dwell in a neutral state, sometimes known as the zero state, or the source. The phrase "back to the source," which has entered into our contemporary vocabulary, suggests a returning to the land, to a time when people were conscious of honoring the earth, the rhythms in nature, and the sacred ordering of days, seasons, and years. It evokes a remembering of the wholeness of the activities that spring from and return you to the source. The results of these creative projects can bring about feelings of tranquillity, centering, and as the title of this book suggests, inner peace. This peaceful feeling indicates that you have connected with the source of your happiness and well-being.

Creating Yantras is a traditional spiritual practice that, just like yoga and meditation, leads you to the source, to a feeling of contentment. Yantras were originally conceived over four thousand years ago in the northern regions of India. Creating Yantras is a particularly powerful spiritual practice that enables you to connect your essential creative self with its expression. Working with these designs has become part of contemporary stress-reduction practices brought to us from the East along with yoga and Eastern philosophies.

Each of the Nine Designs, or Yantras, possesses distinct qualities expressed through differing shapes and color configurations. Your mind, body, and spirit respond differently to each one. Creating these designs in an active form of meditation leads you to inner peace by quieting the chatter that flows unhindered in your mind.

There was a time I went about my usual activities mindlessly, just doing them to get them done, wishing they would be finished and out of the way. Usually they would be uninspiring and leave me feeling rather tired. From the teachings I have absorbed through Yantra painting and the studies I had with Harish in India, I have learned to view these activities in a new light. There is no rushing to get through this project to get to the next thing, and the next one after that. The joy of fully engaging in the task at hand, whether it is cooking a soup, or carrying the groceries home, has become the source of immeasurable happiness. It has been a gradual shift, but there is a qualitative difference now in my experience during and after these activities. This shift has been inspired by the process that I am outlining in this workbook. The ease and flow of various activities during my day is more of a celebration of the vitality of each moment. I am energized by my daily routine, rather than drained by it. It is my wish that the spiritual practice of creating Yantras brings you a deepened awareness of the richness of the present moment on and off the paper. All spiritual practices such as Yantras, yoga, and meditation can be done in a dry, dull fashion. It is the desire to use them to enliven your vision, your views on life, or to feel calm that will enrich the practices themselves as well as the good feeling and peacefulness that continues throughout the day. Through teaching numerous workshops on Yantras, I enjoy witnessing how the benefits ripple out into the lives of my students.

This process becomes astonishing when you realize that you yourself are the catalyst for the benefits that we speak about in this book. The spark that will ignite the deeper teachings given here comes from within. Choose to fully engage in the "art" of creating Yantras in a way that triggers your full-hearted attention; this will help you to cultivate the state of mindfulness. The invitation comes through this ancient practice. The extent to which your life will be enriched is up to you.

Key Qualities of the Nine Designs

While working with the Yantras, you will tap into the timeless key qualities of these ancient designs and arrive at some new understandings of their benefits and powers. The brief descriptions here introduce the key qualities and synthesize the more expanded discussion later on. As you make your Yantra, running these few words through your mind will maximize the benefits you receive from your chosen design.

Radiance: Sunny optimism, self-confidence, magnetism. Enables your joy and good spirits to reach and affect others you connect with.

Nourishment: Nurturing, sustaining, compassionate. Cultivates feminine and receptive attributes.

Passion: Direction, purpose, enthusiasm. Allows you to compete and accomplish great feats with desire, meaning, and joy.

Intellect: Judgment, equilibrium, balance. Calms the nervous system and stimulates the mind toward equanimity.

Expansion: Growth and opulence, generosity of spirit, and community. Opens your heart to opportunities for charity and sharing and suggests new horizons.

Bliss: Sensuality, appreciation for beauty, art, and refinement. Gives you access to the positive aspects of your senses.

Organization: Order, discipline, a quiet mind. Patience and endurance are maximized.

Uniqueness: Independence, originality, exploration. Awareness of your authentic voice and ideas.

Spirituality: Mystical experiences, solitude, purification. The peace you find within.

The use of words in the Yantra-making process helps to shape the outcome, to find out where, for example, uniqueness is awakening in your life as you create the Uniqueness Design. This adds a rich dimension to the practice—one of self-discovery—as ideas, feelings, and thoughts surface throughout and long after the practice. You may find barriers to your own uniqueness that you are able to dispense with over time. Ideas may emerge as you make the Yantra for the first or tenth time, or as you meditate on it later.

In addition, each design has a sound that resonates with its key quality. By listening to or reciting the sound while focusing on the design, you will amplify its heal-

ing potential. (Additional discussion will follow on the importance of sound in the Yantra-making process, as well as the specific sound that corresponds to each of the key qualities.) Sound is a wonderful vehicle for self-expression—freeing your voice through singing or chanting liberates your creative spirit.

The steps for making a Yantra described in this book, using the ruler and compass for exactitude, remove the need for you to puzzle out the geometry of the Yantras. All you have to do is immerse yourself in the activity, and the key qualities contained within the designs will be communicated to you even if you are unaware of it. You will discover, though, how much more effective it is if you purposely direct your mind to welcome the specific quality of the design you are making. This is what I mean when I speak of a conscious or mindful experience to contrast with a merely mechanical activity. For example, the Nourishment Design awakens the ability to nurture and nourish your body, mind, and spirit through the specific colors, shapes, and sounds as well as through your intention to nourish.

As you create the design, a visceral response occurs with positive spiritual results to the body and mind. While each design has its own specific quality, the centering effect is the same with all Yantras. Working from the outer edge toward the center mirrors the journey of discovering peace within. For example, if you are agitated and restless at the start, by the time you arrive at the center of the Yantra, you will have reined in those anxieties and arrived at a place where the mind is clear and the body feels settled.

The Benefits of Working with the Nine Designs

Naturally you are wondering how creating a particular design will affect your life. In part that depends on the way you approach the activity. The workbook guides you in great detail concerning how to execute the drawings, how to color them, and even how to use them for meditation. In this section you will discover what you yourself can do to derive the greatest benefits from this practice.

Enhanced Creativity: Simply by opening yourself to the process of making the design you will connect with your creative resources. This is not merely in an artistic sense, but also in how you address with imagination and originality everything that comes your way.

Reduced Stress: Both the process of making the design and the targeted qualities of each one help alleviate the stress and chaos most of us are exposed to daily.

Valuing Your Surroundings: The combination of color, shape, and sound involved in making the Yantra will contribute to your appreciation of your environment—your awareness of your home, your clothes, and the things that make up your world.

Trusting Yourself: By creating the design that you first are attracted to, simply from intuition, you will garner an inner trust in your response to things and people around you.

Inner Peace: The habits of mindfulness you form based on this design-making experience can be applied to all your daily activities. This is the supreme benefit of creating Yantras.

Enhanced Creativity

By connecting with the source of your creativity through this spiritual practice, a vibrant energy is awakened that will bring its inspiration fully into your life. The students who attend my workshops report back that afterward their lives are back on track vis-à-vis their creativity. Recently a woman who had not painted since kindergarten produced a stunning Bliss Design. A writer who had lost touch with the joy in writing told me her words had begun to flow again, inspired anew by the depth of creativity she was now feeling. Students often report a joyful wholeness reentering their lives, as if their lives have gone from black and white back into color! There is an ease, a happiness, and a relaxation that come from remembering the source of your being through this traditional form of active meditation.

I have made these designs over and again, and it is through the simple repetition of their creation and the familiarity with their forms that I have found the most positive results. When you embark upon a spiritual practice, its fruits are always more glorious when you devote sustained, regular effort to it. Soon the immediate fruits, whether a finished painting, a comfortable hour of silent meditation, or a steady headstand, are less rewarding than the strengthened connection to the source, which is the true result.

Reduced Stress

The benefits of this form of active meditation lie in reducing stress, or changing our response to it. When creating the Nine Designs, the process itself soothes stress. As the triggers to stress are resolved by invoking the key qualities, there is even further relief. For example, if you are stressed because of the chaos in your life, the process of creating the Organization Design will be calming, while the effect of working with

organization will awaken the knowledge to resolve or find order in the confusion that is currently overwhelming you.

We know that when we are tense or anxious the breath becomes shallow and fast; conversely, when relaxed the breath is deep and full. Breathing techniques are designed to calm the body and mind; meditative activities such as creating Yantras have a similar effect. As one student, Lesley, told me, "The Yantra has been so powerful. I put it on my wall at home. It's amazing, Sarah. I feel so soothed and protected by the Yantra. I really feel like it breathes and helps me to do the same. I want to paint more and more." Having found a degree of relaxation and contentment from her first Yantra, this woman wanted to create more. Her response is quite typical. She connected with a feeling that had been missing in her life and experienced increased well-being from a practice that she found easy to do. Keeping the finished painting on her wall at home served as a constant reminder to her of the state of well-being she achieved during its creation.

Once the designs are on the wall at home, or in some significant focal point, you will begin to see how the images come to life. As you spend more time with the designs, the colors and shapes will suggest new aspirations and ideas. The designs may develop a kind of animated feel, like Lesley's, which seemed to breathe.

Singing the sounds associated with each design, known as *mantras,* can be liberating, taking you out of a rigid, constricted way of acting. Everyone knows the joys of singing in the shower or singing in church. Chanting, humming, hearing a song in your head—in so many ways sounds produce a joyful response in the spirit. How hard it is to be tense and angry and still sing joyfully!

Valuing Your Surroundings

Playing with color, shape, and sound within the format of the Nine Designs has an incredibly freeing effect. In the Intellect Design, for example, the range of greens and blues in relationship to the shapes can be playfully investigated; each time a new result will appear if you let yourself experiment and try out some variations on the predictable color combinations. By trusting this exploration within the guidelines, you will develop confidence and joy in the use of color, shape, and sound in everyday life.

Perhaps you will be inspired to choose the colors of your clothes based more on spontaneously going with your fundamental feeling that day, rather than according to a plan. You can choose to paint rooms in your house with colors that have a positive effect on you. I have observed that even without changing anything in my

environment, it often appears different after my work with a Yantra. I can see the true beauty of the colored water glass; hear the pitch of the wind chimes that were always outside my window; distinguish the shapes of the leaves on the tree in the yard as the sunlight pierces the spaces between them, sending an array of greens, yellows, and warmth in my direction. Life just seems richer. It's like one of those times when you are walking down the street—the same street that you have walked down for the past few years on your way to work—and you stop for a moment in awe of the beauty that surrounds you. Today you stop and notice and thereby enhance the quality of your daily commute.

Trusting Yourself

I encourage you in this workbook to follow your intuitive choices. This pays off when it comes to acting on a spontaneous idea, or not mulling over the color of the sweater you decide to wear today. The joy that arises from these seemingly instant decisions comes from somewhere deep within.

The process of selecting, drawing, and coloring the Nine Designs contains countless opportunities to trust the intuitive, creative part of yourself. Daring to follow your gut reactions to color selections and mixing paint allows a deeper truth or result to emerge. Throughout the process you can see how this form of meditation is not only for connecting with your creativity but can also become the source of your happiness, your inner peace.

Inner Peace

As you can see from the benefits outlined here, your ability to experience the deepest results comes from a multi-faceted approach. As you progress with the creation of the Nine Designs you might like to reread this section. Reading about the benefits of a practice will make them come to life in a recognizable way. For example, noticing the ways you are now trusting yourself or reducing stress in your life will be encouraging—serving as signposts along the way. The more you are inspired by your part in the spiritual journey, the more fulfilling it will be.

This outer practice, geared toward an external form of meditation, will also enliven your inner life. I have discovered by making the Nine Designs over and over that a tranquillity arises from within when I close my eyes to follow the sounds, colors, and forms that are inside. Inner and outer become less distant when the spaciousness inside permeates your activities. The opposite is also true, when the outer joys draw you silently within. This is the experience of inner peace. There is much to explore

in this workbook, and the creative process is infinite. Yantras can take you to nirvana and back, with a lot of fun along the way!

The Creative Journey

This workbook has been created to enable you to benefit from the magical process of choosing, drawing, and coloring the Nine Designs. By selecting the design that resonates with you and working through the steps toward its creation, you will taste the fruits of the age-old practice of Yantra painting. Just as yoga and traditional seated meditation have long been known as accessible paths to inner peace, the creation of the Nine Designs takes a place alongside them for its instant access to a creative, healing experience.

The material in this book is presented in a methodical way, introducing you to the elements required to engage in this practice fully, whether you are new to Yantras or are at a stage where you would like to receive some of the deeper teachings. You can choose to draw the entire design yourself or to color one of the outlines provided in the appendix. Choose the method that is the most appealing to you at this time—the one you can do now. Getting your hands wet is the only way to fully experience the joys of the Nine Designs. By *doing*, rather than merely observing, you will awaken your creative faculties. The process will become clearer and will appear paradoxically more simple as you progress to the more challenging aspects.

Dive In

I encourage you to begin, as I did, without extensive research and questioning. Pretty soon after embarking upon the drawing practice, I found the hidden "logic" of the collective geometric forms. Even without a background in mathematics, the universal patterns that reside within the forms began to appear to me. The colors in each design have become easier to mix and place on the paper over time. I am confident that if you dive in and begin this practice without hesitation, your ability to create and understand the power of the Nine Designs will inspire immeasurable potential for their use in self-healing.

Each design contains a specific arrangement of geometric forms and colors. The nine names echo the meaning imparted by each design, such as the Passion Design, which elicits a fiery dynamic quality. As you work with them you will find additional personal significance in each one.

Choosing Your Design

In chapter 1, the Nine Designs will be displayed on one page—to see them together, take a look at page 18. Choose the one that attracts you most from the group. Trusting your initial response to the images is a large part of the selection process. In this first step you can begin to throw off preconceptions and expectations by resisting the urge to make a logical process of decision making and by not worrying about choosing the "right" design to start with. Give yourself to the first design that reaches out to you without asking why.

The Outlines

Completed outlines for each design are provided on pages 161–69. At first, the step-by-step drawing method may feel like one step too many, in which case, this option is for you. Once you have chosen your design, you can select and copy the outline by either tracing or photocopying the lines. This is a great option for those of you who would like to see quicker results. With the outline in place you are ready to color the design and soon you will have the completed image ready to meditate upon in stillness.

Creating the Shapes: The Step-by-Step Instructions

To familiarize yourself with the individual shapes, the *ingredients* for the Yantra, see chapter 3. You will learn how each shape conveys rich symbolism and meaning connected to the specific Yantra with which you will be working. Reading through the step-by-step instructions for the shapes' creation before beginning the drawing process will help you to see how all of the steps come together to create the final form.

The Recipes

For each design the color and combination of shapes differ. In chapter 4, Recipes for the Nine Designs, you will find the instructions needed to create your specific Yantra. Here, the ingredients—the shapes and key colors—are given along with additional tips for cooking up your chosen design.

The Mantra

In the recipe section you are also given the *mantra*, the healing phrase or sound that corresponds to the specific design. There are nine mantras, one for each design. When you are drawing, coloring, and sitting with your design once it is finished, it is helpful

to recite the accompanying mantra. There is a resonance between the image and the sound. When you use the two together there will be a focusing of the mind and senses toward the healing energy of the design. Read more about the mantras at the end of chapter 2.

Everyday Mindfulness

Once you are comfortable with the creation process, turn to chapter 6 where I offer in-depth ways to meditate with your design. Here you will find some useful information on the optimum ways to explore the meditation practices. Be sure to look at chapter 7 as well for the ancient tradition behind the Yantras. I found that after working with the forms for some time the inspiration came to delve into their origins. This historical information highlights the timeless qualities within the Yantras and brings a vitality to the "here and now" of the images today. The Nine Designs will influence how you perceive color, shape, and sound in your daily activities. To integrate the lessons you learn throughout the workbook, read chapter 8 to see how to make a seamless transition between this spiritual practice and your everyday life. Enjoy the journey!

1 Creating Your Personal Yantra

1 Choosing Your Design

One of the most revealing moments in the process of creating a Yantra is discovering which design you will choose. This is a fun and freeing opportunity to relax and allow deeper energies to guide you. The results are often surprising!

The colors, shapes, and the associated sound vibration of the Yantra communicate on a primal level. They penetrate beyond the layers of words, thoughts, and desires that belong to the "shoulds" and "wants" of the external world. The Yantra you paint will correspond to a quality that will benefit you greatly at this time. In preparation, quiet the mind, emptying it of expectations and self-critique.

Sitting in this receptive state of mind, place the page displaying the Nine Designs (p. 18) in front of you. It will seem at first as though you are selecting the one you like the most—the colors that appeal to you at this moment in time, the shapes and vibrations that resonate with you. In another instant it might appear that they are choosing you. Gazing at all the designs, the one that is most helpful for you now will be the design that "jumps out" at you.

Often the colors we need to bring ourselves into balance are not the ones we are habitually drawn to. For example, if you surround yourself with the pastel colors of mauve and pale blue, you may be surprised if the Passion Design, filled with bright

reds and pinks, jumps out at you. Trust your instincts. The bright colors are now speaking to you. If you second-guess and remind yourself of your preference for pastel colors, the potential for personal growth offered by this process will be nullified. It is quite possible that the energy of the Passion Design is needed for you to make progress in a certain area of your life; only by following through and creating this design will that become clear. Opportunities to take risks, try something new, or trust a voice that guides you in an unfamiliar direction will be made available to you. Each Yantra comes to you exactly when you need it in order to move you toward the place that is whole and complete.

This is a valuable exercise. If you trust the results of the most spontaneous choice, your relationship with your intuitive self will be enhanced. Each time you listen and respond to the voice within, it becomes encouraged and grows stronger. The voice of knowing is like a muscle that weakens if underused. When you start to hear what it has to say, a strong channel develops between the inner voice of the spirit and the inquiring mind. This selection exercise is useful not only for choosing the Yantra that will resonate most with you, it is useful in a larger context to encourage you to begin playing with the faculty of intuition and following your "gut feeling" in daily life.

Each time you create a Yantra the selection process is renewed. You will probably make each of the Yantras in this book more than once. The repetition of a design's creation is essential to fully comprehend its effect. The joy of creating one Yantra over and over is in noticing the changing nuances of the colors and lines, the feeling of the chosen color range, and the varying response in your body, mind, and emotions.

The process of creating your Yantra begins with the thought that you are "doing this to achieve that"—performing an external activity that creates a concrete result. For example, by making the Bliss Design you may intend to bring more blissful feelings into your relationships. I have found that on this level creating Yantras is immensely rewarding. In addition, after creating the same design multiple times, it is my experience that the spiritual dimension is further awakened. It is this magic that arises through repetition that is at the crux of the Yantra's use in spiritual practice. There is a deepening that occurs through repetition, accompanied by a devotional feeling that something larger is at work, inviting surrender to the subtle universal forces.

Creating a Yantra is a powerful sacred practice that encompasses many life lessons and teachings. The ancient seers of India over countless generations have helped us connect our individuality with the deeper impulses that guide and shape our lives. How fortunate we are that these mystics *saw* the connection between the mundane and the sacred and gave us the tangible form of the Yantra to help awaken that connection within each one of us.

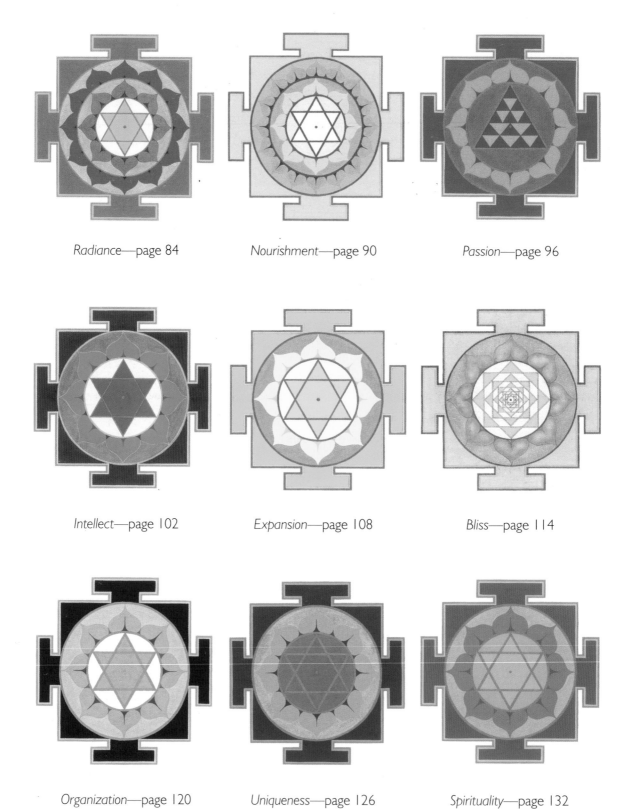

Radiance—page 84 *Nourishment*—page 90 *Passion*—page 96

Intellect—page 102 *Expansion*—page 108 *Bliss*—page 114

Organization—page 120 *Uniqueness*—page 126 *Spirituality*—page 132

THE NINE DESIGNS

Choosing Your Design: Step-by-Step

- Create an atmosphere conducive to selecting your design and quieting the mind. Sit in a comfortable, quiet spot in your home, free of extraneous noise and clutter.

- Candles, incense, flowers, and soft music may enhance the devotional mood.

- Close your eyes and take a few long, deep breaths. Feel your body in its seated position becoming more comfortable and relaxed with each breath.

- Chant the sound OM or AH three times. These sounds will clear the mind, relax the body, and prepare you for something new.

- Open your eyes and gaze at the Nine Designs on the facing page.

- Look over the entire page absorbing the colors and shapes.

- See if there are any designs that speak to you in this instant.

- There may be several designs that attract you at first, but after a few moments there will be one whose colors appear the most vivid to you today.

To find out more about your chosen Yantra turn to the corresponding recipe in chapter 4. Read the entire section on your design before beginning its creation.

2 Materials and Techniques

This chapter will guide you through the materials you need to create your Yantra and give you tips on working with color.

Materials

You will need the following materials to create your Yantra. If you would prefer to begin with one of the completed outlines provided in the appendix, you can skip ahead to the Coloring section.

Paper: One block or pad of 12 x 15-inch 140 lb watercolor paper. Use cold-pressed paper, which has a slightly rougher surface, if you will be applying color with gouache paint. You can use hot-pressed paper, which is smoother, for colored pencils.

Pencil: A sharp, medium weight, 2H/2B pencil with a pencil sharpener. Or a mechanical pencil—preferably with a 0.3–0.5 mm lead.

Ruler: A transparent ruler with faint grid lines.

Eraser: One with sharp corners.

Compass: Use a mechanical drawing compass rather than a compass with separate pencil; this will make the process much easier! Make sure you have spare leads to keep the point of the lead sharp.

Drawing tools

Coloring

Color may be added to the Yantras either with pencils or gouache paint. In the design recipes in chapter 4, you will find the suggested color range to work with for your chosen Yantra in the medium of your choice.

COLORED PENCIL OPTION

You will need a set of twenty-four colored pencils, a pencil sharpener, and plain white paper on which to test your color range.

Colored pencils

GOUACHE PAINT OPTION

This water-based paint is opaque, which results in a smooth, flat look. The colors I recommend you start with are:

White: permanent
Blue: ultramarine, cerulean, and prussian
Red: spectrum red and scarlet lake
Violet: magenta and rose tyrien
Yellow: lemon, golden, and yellow ochre
Green: permanent green and viridian lake
Brown: burnt sienna or raw umber
Gold and silver: these are "imitation" water-based metallic paints

For the painting option you will also need:

Mixing palette: To hold the paints and mix the colors.
Mixing brush: One soft, thick brush (#3–#5) for mixing the paints. An old paintbrush is ideal.
Painting brushes: You will need three brushes, ranging in size from #000 to #4. You will use a fine-pointed one (#000–#0) for painting the thinner lines and a couple of larger ones (#1–#4) for the larger areas. It is most important for the brushes to have good points, so check this out in the store before you purchase them.

Gouache paint

Drawing your Yantra in good light

Water container: A plastic or glass jar.

Newspaper or plastic covering: To protect your work surface from being stained by the colors bleeding through or by spills.

Scrap paper: To test your colors and absorb extra paint.

Workspace Essentials

Good Light

Whether you are working with artificial or natural lighting, please give yourself an abundant supply. Set up your desk or drawing surface in a position where you can sit comfortably and where your eyes are given ample light with which to see. Most drafting and close drawing projects require three times the intensity of light that a normal living environment would need. It is incredible what a difference it makes both to the beauty of the lines and to the painted colors when there is good light—not to mention the ease it gives the eyes.

Peaceful Atmosphere

Equally important is the comfort of your body. The drawing and coloring takes time. Whether you are seated on cushions on the floor using a low table or sitting in a chair at a desk, the body has to be comfortable. Using a part of your home that is

reserved for activities such as yoga and meditation is ideal. The atmosphere will be conducive to relaxation and a meditative awareness, which will enhance your creative experience. If you have no separate space available, consciously clearing and cleaning the area you will use invites an attitude of readiness for the practice into the space. If you are painting, you will need a solid surface to place the water, mixing palette, and paints close to you.

Working with Color

Working with color is both a science and an intuitive process. Learning comes by experimenting with materials, color combinations, and line thickness. There is certainly more than one way to work with these elements, and by following your creative impulses you will develop a "palette" of color and texture that reflects your personality and spirit.

The colors for the Yantras are based on archetypal principles corresponding to the planetary associations of the Nine Designs. For example, the Passion Design relates to Mars and Mars relates to the color red, but not every Passion Design created will use the same type of red. The shades and hues of red will vary depending on the characteristics and sensitivities of the artist. Always go with the color that feels right to you and not the picture perfect match to the one in the book. (The colors used here reflect my personality not yours!) The Color Notes provided within the recipes in chapter 4 will give you general guidelines to work with while enhancing your own relationship to color. You will discover your own palette within this structure. By giving yourself some freedom here, the magic of working with color and the healing it produces will rise to the surface.

To begin with it is useful to have some spare paper by your side to test the range of colors you will use before committing to the Yantra paper. Once you have placed the color within the Yantra, however, take this as a divine choice. Resisting the urge to "fix" or meddle with the color once it is down is part of the surprising and revealing process. Often a color I am compelled to put down looks strange at first, but by the time I arrive at the center of the design the complementary colors within the whole image find a balance and harmony I could not have predicted earlier.

With each construction of a sacred Yantra your coloring skills, both the mixing and choosing of colors and the technique with which you apply the color, will be refined. As with any art, the key is practice, practice, practice!

As with the drawing process, applying color is done from the outside to the cen-

ter, spiraling inward in a clockwise direction. Take time to become quiet and focused before placing your hand on the paper. Take some deep breaths to relax yourself. Long exhalations can provide a supportive background to brush or pencil strokes. There is no rush to complete the design, absorbing yourself in the coloring becomes a meditation in itself. You will find that much arises and clears in the mind as a result of the process.

Colored Pencil Technique

Using colored pencils is a great way to put clean, clear colors on the page. You can experiment with mixing different-colored strokes and varying the pressure you apply to attain an array of visual effects and color vibrancy. Testing the colors for your design on the scrap paper is a helpful way to see the colors placed next to each other and to begin developing a feel for the palette you will use.

Shading—creating areas of light and dark within a shape—is an effect that is easily achieved with colored pencils by varying the pressure you use when applying the strokes. You can create a more three-dimensional form with the petals, for example, by shading.

Keeping the pencils clean and sharp ensures clearer definition of color within the form you are filling. There is no end to the combinations or color effects you can achieve with twenty-four pencils. If you don't have colored pencils, wax crayons will also work, giving a brighter feel to the design.

Coloring your Yantra

Painting Technique

Using gouache paints to color your Yantra creates rich and stunning colors. Gouache is also a very user-friendly paint. Due to its opacity, mistakes can be corrected or covered up by the next color. Mixing the colors is a fun way to get into the feel of the specific design you are coloring. A red out of the tube, for example, might need a little white added to make it feel like *your* red. Strong and harmonious color relationships within the Yantra are explored through your initial work mixing and refining the colors to suit your needs.

PAINT CONSISTENCY

Mix the gouache paint with water to create a consistency that is smooth and fluid without being liquid. Whether you are using one color straight from the tube or mixing two or more colors to create a new color, water is needed to create your medium. If the paint is too thick, it will not cover the paper evenly and will take extra effort to apply. If the paint is too liquid, it will run out of the shape it is filling and the colors will not cover evenly, leaving the surface beneath visible in places. By working slowly with the paint and its application you will develop a feel for the consistency that is just right.

TESTING THE COLOR

Test the color you have just mixed on a piece of scrap paper. Paint changes its appearance when dry, sometimes drying lighter and sometimes darker depending on the pigments. When you have your sample, make sure you are pleased with it by placing it next to the previous color on the design and seeing if there is a harmonious relationship between the colors.

WORKING WITH YOUR BRUSH

Use a brush with a good point. Start slightly away from the edge of the shape you are filling and work toward the edge, being careful to stay within the outlines. Have a piece of scrap paper close by to absorb excess paint from your brush before working on the Yantra. When not using the brushes, keep them resting on a flat surface—if left in the water jar they will lose their form. To mix the colors, use an older or less delicate brush. Stirring the paint to thoroughly mix the colors is hard work for the brush and quickly renders the bristles useless for fine work.

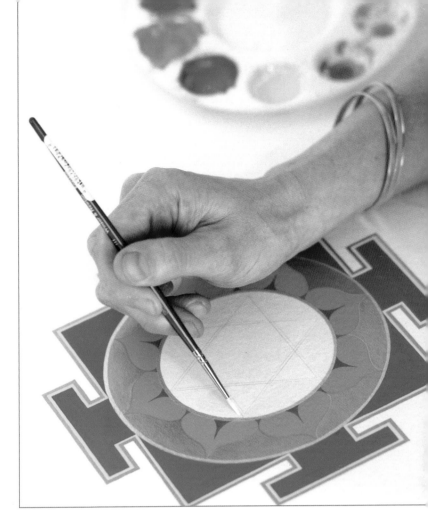

Painting your Yantra

AVOIDING SMUDGES

Gouache paint has a quick drying time, which, thankfully, eliminates the majority of paint smudges. However there are a few actions I like to be aware of as I paint to further prevent the blurring of colors. Waiting for the previous color to completely dry before applying the new color is helpful. To steady my brush as I paint, I place a piece of scrap paper directly underneath my hand. Resting the weight of my hand on the paper allows me to use the brush in a precise and "weightless" way. In addition, the scrap paper eliminates hand smudging and also prevents the hand's natural body oils from seeping into the paper.

REMOVING UNWANTED MARKS

Once in a while the paintbrush seems to have a life of its own and random spots of color will appear on the page somewhere other than in the intended shape. If this happens, it is best to try to remove the paint immediately. If it has landed on a plain part

of the page, take a clean paintbrush soaked in clean water and drop a little water onto the paper over the mark to dilute the paint you are hoping to remove. In effect you are lifting the color out of the paper by diluting the area and then soaking up the water. This lift can be done with either a clean, dry paintbrush or the corner of a paper towel. You may have to repeat this process until the color disappears completely. If the paint has accidentally landed over another color, the way to remedy this is by covering it with the original color. For this reason it is important not to discard any mixed paints until the whole design is completed.

Working with the Mantra

Just as bringing your awareness to the ingoing and outgoing breath is relaxing and supportive to the coloring process, the addition of the mantra will enhance the meditative effects of creating your chosen design. Reciting the appropriate mantra while you apply color is the best way to fill the atmosphere with the vibration of the design you are creating. The mantra affects the atmosphere of the room you are in as well as the atmosphere of your thoughts. This purifying effect will be a tremendous aid to your concentration throughout the creative process.

There are many ways to work with your mantra. It is helpful to say the mantras out loud at first to fully hear and imbibe the sounds. The mantras are given in the recipe sections in their phonetic form. The sound vibration is related to the colors and forms within the chosen Yantra. By really listening to the sounds as you recite them you will be influenced in a positive way to mix the perfect colors for yourself. You may choose to sing the mantras in a tuneful way. Engaging your mind in the activity of singing is stimulating to the creative process. It is a strong way to occupy the senses, slowly quieting extraneous mental chatter and attraction to external stimuli. Repeating the mantra silently creates a deeper connection to the stillness within. I like to spend time repeating the mantra aloud for a period at the beginning of the coloring. After a while my energy feels more contained and the mantra seems to emanate in silence from within. Try it and see for yourself.

You will find the accompanying mantra for each design in chapter 4 and can read more general information about mantras in chapter 7.

3 The Wonder of Shapes

Sacred Yantras are made up of the following components: the bhupur (outline); circle; petals; triangle, six-pointed star, or square; and bindu (central dot). Most of these shapes are purely geometrical and relate to the cosmic laws of sacred geometry. Sacred geometry is a pre-linguistic form of communicating through basic archetypal symbols; it has been used in various forms throughout civilization. It is the shapes' placement on the Yantra, centrally around the bindu, that gives the forms a magnetic charge. The elements are placed to bring your eyes from the outside to the center, mirroring the spiritual practice of harnessing the mind from its wandering tendencies to rest upon the object of perception and bring you to rest peacefully at the center of your being.

The only purely nongeometric form used in the Yantras is the petal. This form is thought of as the lotus petal directing your gaze inward to the center. The petal directs the lower mind to the higher mind or consciousness. Drawing the petals freehand (with the help of the semicircular guide) can bring a feeling of connecting your personality with the Yantra. The freeform of the petals is juxtaposed with the more structural universality of the geometric shapes. This merging of natural shapes with the strictly geometric forms is a beautiful aspect of the Yantra.

INDEX OF SHAPES

Bhupur p. 32

Circle p. 44

Petals p. 47

Triangle p. 61

Six-Pointed Star p. 69

Square p. 74

Bindu p. 80

Please read this chapter carefully to learn the significance of each shape. By reading through the step-by-step drawing instructions before creating your Yantra, your knowledge of the inherent logic of each shape as it sits within the horizontal, vertical, and diagonal lines of the design will aid greatly in their visual manifestation. As you work, always start at the top of the page and move around the Yantra in a clockwise direction.

Bhupur

The first pencil marks you will make on your page are construction lines for the *bhupur*. The bhupur is the outline and is used in each of the Nine Designs. Also known as the gates, the bhupur marks the beginning; the lines of the bhupur denote sacred ground and pave the way for the developing Yantra. The structure is supported by the horizontal, vertical, and diagonal guidelines that are the foundation for almost all of the shapes within the Yantra.

The gates consist of four protrusions representing the four cardinal directions of the compass: north, east, south, and west. The energy from each of these directions is invited into the form. The corners of the bhupur represent the northeast, southeast, southwest, and northwest. The gates draw the eye inward to the center, which points you toward the higher realms.

Bhupur is a Sanskrit word formed from the root words *bhu* (earth) and *pura* (city).* The word holds great power, for Sanskrit is a language in which words are formed to resonate with the vibration of the object being described. Thus bhupur on a vibrational level imparts the meaning or sense of the gates.

And so the bhupur is a gateway from the terrestrial world (earth city) to the celestial world. The gates are the crossing point from the mundane realms to the celestial realms; the Yantra itself is the embodiment of the sacred, of spirit in geometric form. The Yantras are read from the outside in, from the circumference to the center. This mirrors the viewer's journey from an individual viewpoint in the outside world to the universal, spiritual dimension within. Here, the word's meaning and the journey itself are both pointing you in the same direction. By drawing the bhupur you are heading into the sacred space.

I see the gates rather like the walls of a walled city, or the boundaries of a temple. Within architecture the three-dimensional form of the gates can be seen in courtyards, around mosques and churches, and in cloisters within which people can wander freely, protected and alone. The space offers solace and some quiet time. Demarcation with a line or a wall acts as a positive boundary encapsulating and raising the energy

*Definition of bhupur obtained during an interview with Dr. Robert E. Svoboda.

level of the interior space and claiming its sanctity. It becomes a space in which people can contemplate their lives and pour into it their feelings of reverence and devotion. The two-dimensional Yantra is created within the sacred gates of the bhupur, offering a soothing and spacious resting place for the gaze, a quiet meditative environment in which to become peaceful and centered. The gates are a vast entryway into realms where all things are possible.

DESIGN NOTES

This is the outline and beginning of the Yantra. As you draw the lines try to produce the most beautiful and clean shape possible. The feeling of the outline will influence the outcome of the rest of the Yantra. Be clear and calm as you draw the lines; keep your breath long and even and your lines equally clean and clear.

Note: Much of the drawing here will be erased once the outline is complete, so try to keep your lines light.

The Yantra presented here is a specific dimension that I like to use, but the Yantra can be made in any size that pleases you. As you will see, the form is created by the relationship of the marks, circles, and guidelines. It is constructed more through proportional measurements than strictly numerical ones.

1. Find the center of your paper (a 10- or 12-inch square page is ideal) by drawing a faint line diagonally from the top left-hand corner to the bottom right, and from the top right-hand corner to the bottom left. Where the lines cross is the center.

Place the point of your compass at the center and draw a small circle with a one-inch radius. The radius is the distance between the lead and the point of the compass. This circle will be used as a guide. Erase the diagonal lines.

2. Using your ruler, draw one horizontal and one vertical line through the circle. Make sure they intersect the center precisely. (You will feel the pencil sink into the indentation left by the compass point.) These lines, which will be at least eight inches long, are the hori-

zontal and vertical guidelines. Place the word OM or its sign 🕉 centered at the top of your paper. This will mark the top of the design, indicating your starting point throughout the drawing and painting steps.

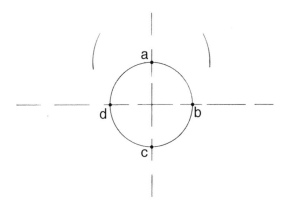

3. To create "true" diagonal guidelines you will bisect (divide in two) the spaces between the horizontal and vertical guidelines. Bisecting is a large part of creating the Yantra, so pay attention here.

 Place the compass point on (a) and the lead on (b)

to create the desired width of the compass arc. With the point still on (a), swing the lead out between (a) and (b) toward the diagonal, leaving a small mark. Now swing the compass lead out toward (d) and create the second mark.

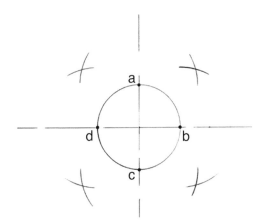

4. Maintaining the same distance between the compass point and lead, place the compass point at (b) and swing the lead up toward (a) creating a cross by drawing a new mark across the existing one. Keeping the point in place at (b), swing the lead down toward (c) to create another small diagonal mark.

Now place the compass point at (c) and swing the lead up toward (b) to create a cross and then up toward (d) to create the new diagonal mark.

For the final step, place the compass point at (d) and swing the lead down to cross the mark between (c) and (d) and up to cross the mark between (d) and (a). You will now have four crosses.

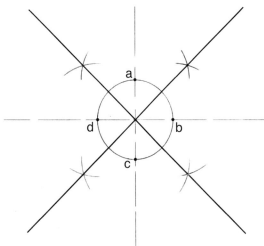

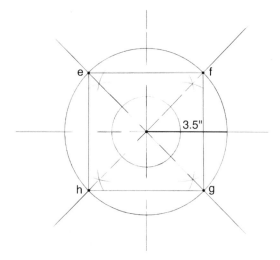

5. Take your ruler and draw the diagonal lines through the crosses and the center exactly.

6. Draw the outer circle by placing the compass point in the center and expanding the width between the compass lead and point to three and a half inches. This circle encompasses the whole Yantra. Connect the corner points (where the diagonal lines touch the circle) to create the four sides of the square.

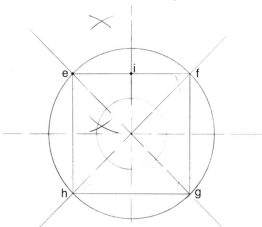

7. Place the compass point on (e) and the lead on (i). Swing the lead above and below the horizontal line (e)–(i), drawing one half of the crosses that will mark the midway point between (e) and (i).

Switch the position of the point and the lead—now the point is on (i) and the lead is on (e). Swing the compass lead across the existing marks to complete the crosses above and below the horizontal line.

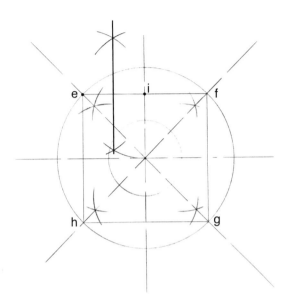

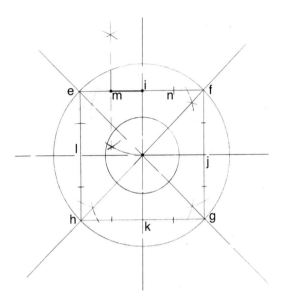

8. Draw a vertical line through the crosses you have just created above and below the horizontal line between (e) and (i).

9. The point (m) denotes the midpoint between (e) and (i). Place your compass point on (i) and your lead on (m). This is the fixed compass width you will use to create the next markings.

To create the next marking, (n), swing the compass lead over to the right and draw a mark (n) crossing the horizontal line midway between (i) and (f). Continue to place the compass point on the central points along the sides of the square—(j), (k), and (l)—and draw the new midway marks on both sides of the central points. You will have eight marks in total.

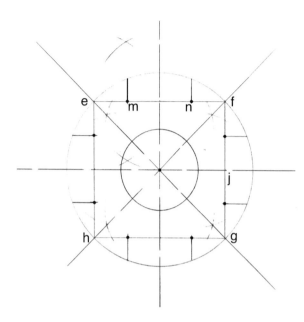

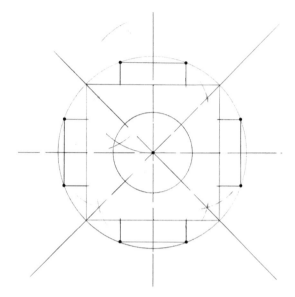

10. Draw the short vertical line from (m) to the outer circle. Moving clockwise—(n) is the next starting point—draw the remaining seven short lines from the midway marking on the square to the outer circle. These short lines will be parallel to either the vertical or horizontal guideline.

11. Drawing straight lines, connect the outer points where the short lines meet the outer circle. This creates the sides of the Yantra.

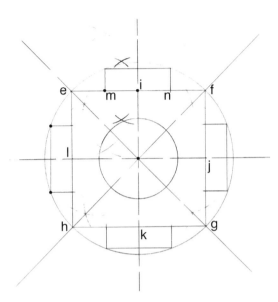

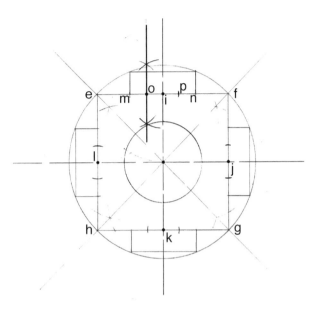

12. Place the compass point on (m) and the lead on (i). Create an arc with the lead, making a mark above and below the horizontal line (m)–(i). Switch the compass placement, so that the point is now on (i) and the lead is on (m). Pass the lead through the first marks above and below the horizontal line to create the crosses.

13. Draw a vertical line through the crosses midway between (m) and (i). The vertical line bisects the horizontal line (m)–(i) at point (o).

Place the compass point on (i) and the lead on your new point, (o). Keeping the compass at this fixed width, swing the lead to the right and make the mark (p) between (i) and (n) on the horizontal line. Continue around the edge of the square, placing the compass point on the central points (j), (k), and (l) and making small marks on either side of the central points. You will end up with eight small marks.

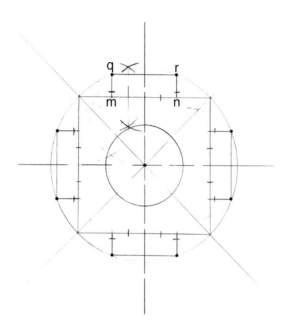

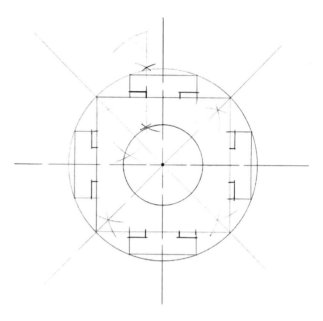

14. Keeping the fixed compass measurement from the previous step, place the compass point on (q) where the outer circle and the top edge of the Yantra meet. Draw a small mark with the compass lead on the vertical line (q)–(m).

 Next, place the compass point at (r) and make a mark on the vertical line (r)–(n). Continue to make these small marks by placing the compass point on the points where the outer edge of the Yantra meets the outer circle with the lead heading toward the square. You will make eight of these small marks.

15. Join the marks you have just created in steps 13 and 14 to create the final form of the gates. The indentation, or cutout shape, created once these short lines are drawn, makes the Yantra come to life.

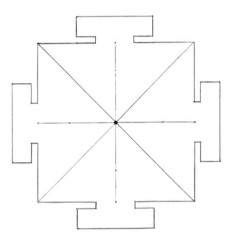

16. Now you can erase all of the extra markings: both circles, the crosses, and everything outside of the bhupur outline. By keeping the horizontal, vertical, and diagonal guidelines and the outline itself, you will be left with the pure shape of the bhupur. Redraw the lines of the outline once the erasing is done to give you a clean, sharp form.

The Inner Gates

Once you have the outer line of the bhupur drawn, the inner gates are created by drawing two parallel lines within the outer line. This involves systematic marking inside of the outer line in preparation for drawing the two new lines. Take a look at the illustration for step 3 to see where the markings will lead. This part takes patience to produce. Once drawn, however, you will see where the outer border will be colored with gold and the inner border will be filled with a lighter yellow, framing the bhupur.

1. To prepare for the double line within the gates, make faint pencil marks of equal length on the inside edges of each corner (perpendicular to the outline). A good measurement to use is one-sixteenth of an inch. Using the same measurement, draw short marks parallel to the Yantra's perimeter. Draw a second mark parallel to your first, again using the same measurement. Continue these marks around the whole form. Note: you can use a ruler to measure the exact distance of the marks, or if you have a good eye, you can make the marks freehand.

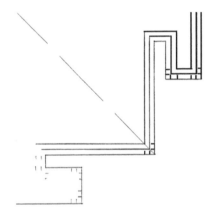

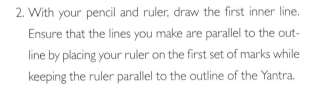

2. With your pencil and ruler, draw the first inner line. Ensure that the lines you make are parallel to the outline by placing your ruler on the first set of marks while keeping the ruler parallel to the outline of the Yantra.

3. Draw the second inner line. Make this line parallel to the outline, creating a second border of equal width to the one created by the first line. You will now have a double line bordering your Yantra.

Circle

Within the bhupur, the circle holds all of the shapes in the Yantra. It is the dominant shape, containing the central area of each Yantra. As a form, the circle can encompass all things. It represents wholeness and completion. The circle is both a closed form and an infinite never-ending shape to meditate upon. The circle has no beginning and no end, and while it can appear empty it contains within it all possibilities.

If you are feeling fragmented, the circle is a very helpful shape to work with. The feeling of wholeness and completeness that emanates from this form can bring a great sense of tranquillity and calm. Concentric circles lead you to the tiny circular form at the center, known as the bindu—calmly bringing you to your center, reminding you in a visceral way that the center of the universe, your connection to the source, is within. The circle is a healing symbol that is capable of taking the fragmented pieces and returning them to wholeness. It never ceases to amaze me how the simplicity of such a form can have such a profound and lasting healing effect.

The circle is suggestive of water and is soothing to gaze at, just as contemplating a lake is equally restful. The Yantras remind me of throwing a pebble into a body of water and watching the resultant expanding concentric circles. This is very peaceful to watch—the circles appearing and then disappearing.

The two-dimensional circle is derived from the three-dimensional solid form of the sphere. The sphere shows us our relationship to Earth, our universe, and the orbits with which we are involved. It gives us a reference point from which to contemplate the other planets and their effect upon us. The phases of the Moon, and the Sun rising and falling, are ways of experiencing the circular forces that govern our lives. As our Earth rotates on its axis and we experience the play of the Sun in response, we experience the circular motion giving us life.

According to the laws of sacred geometry, all forms emanate from the circle and its divisions. The circle represents God—the circumference is that which encompasses all that is and the area then becomes all that is. The circle is the point of origin. It symbolizes oneness; the totality of the universe existing within and shared by each one of us.

A circle denotes a place where a sacred event occurs. Within a Yantra this is the spiritual experience of communing with the energy of a planet or deity and connecting with the sacred within yourself. We refer to forming a circle when people come

together for a spiritual ceremony or union—such as in healing circles, drumming circles, and new or full Moon circles in the Wise Woman tradition. In the Native American tradition, medicine men draw circles around the person who is sick to create the potent space within which healing is possible. In India, sadhus and holy men and women have been known to do something similar. They choose to sit in meditation, within a circle drawn in the earth or formed by a trail of small stones, for a specific period of time. For the designated period of meditation this distinct boundary they have created gives them a feeling of purpose and security and a space for deep mystical experiences to occur. It is interesting to note that circles appearing within the natural world—such as crop circles and the formation of Stonehenge—suggest to us the occurrence of a mystical event.

DESIGN NOTES

With each circle, try to keep the pressure of the lead even, only lifting it once the two ends of the circle are joined. The perfection of the circles and the handling of the compass itself are meditations. It will take your full concentration to arrive at a pleasing image. Connect your breathing with this drawing practice—inhale as you place the lead down and exhale as you draw the circle. Integrating your breathing with the activity can be very steadying to the line and to your mind.

The outer circle is present in each Yantra and will contain the petals. **Note:** When using the compass, press the metal point firmly into the center of the paper. Use a light even pressure with the lead as you draw the circle. Leaning the compass toward or away from you so it is not vertical creates a smooth circular line.

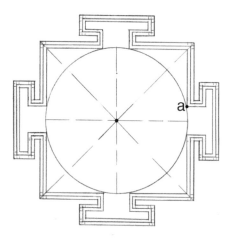

1. Place your compass point in the center of the Yantra and the lead on (a). Draw the outer circle. The circle should just touch the inner corners of the four gates.

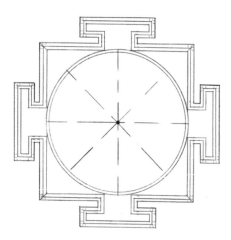

2. Keep the compass point in the center of the Yantra and slightly reduce the width of the compass to draw a second circle. This will create a circular band. The width of this band should be one-sixteenth of an inch, comparable to the width of the bhupur's inner gates.

Positioning the compass

Petals

The lotus petals are the symbol for the purity of the spiritual quest. Their organic forms echo the unique spiritual journey that each of us will take through life. Our individual life path, shaped by the way we flow through and rise out of life's offerings, will influence the way the petals are drawn with their own delightful curves.

The petals are one of the most expressive elements in the Yantra as they are drawn freehand. I like to look at the petals in each Yantra to learn about the person making it; much of the personality is shown in the petals, and they are a nice contrast with the other strictly geometric forms.

The petals in the Yantra rest upon the structure created by the vertical, horizontal, and diagonal lines and direct the gaze toward the center. Traditionally there are eight lotus petals in a Yantra. The number eight represents the five elements (ether, air, fire, water, and earth) and the three parts of our being (intellect, mind, and ego). The twelve petals that appear in the Radiance Design represent the twelve rays of light that emanate from the Sun. And the sixteen petals, used in the Nourishment Design, signify the illuminating beams radiating from the Moon.

The lotus flower is a symbol of beauty, happiness, and eternal renewal. As a symbol of purity, the lotus flower signifies the path of the spiritual seeker, moving through the complexities and baggage (the "dirt") of the individual mind into the clarity and purity of the universal mind. The beauty of the lotus flower is its appearance after coming through the mud. It is pure and stainless white, untouched by its journey. This is a reminder that within each person there is the pure potential for limitless peace untouched by the dramas that life brings us. It makes no difference what conditioning or negative experiences one might have had in the past; all of us, through sustained, sincere effort and devotion, can attain a lasting experience of inner peace. The petals point the way from the external elements (the eight elements of the manifest reality) to the inner light. They impart a beautiful and poetic form to the Yantra.

The lotus flower has long been a symbol of the love that resides at the spiritual heart and the petals themselves resemble the heart shape. Practitioners of yoga believe that there are spiritual centers within us whose radiance can be experienced during meditation. These spiritual centers are represented by lotus flowers, and their opening up signifies the state of supreme bliss. The final opening is depicted in a figurative form as the thousand-petaled lotus placed at the crown of the head.

DESIGN NOTES

Let your petals appear on the page with ease. The shape is not a rigid, mechanical form but rather it loosely follows the semicircular guide and allows for your curves to be revealed. To draw light, flowing lines, steady your hand by resting it on the edge of the paper. This will ensure that you do not dig the drawing lead stiffly into the paper. When I draw the petals I feel my awareness drop down in my body to my lower abdomen. The petals are a less cerebral form to create and require some "letting go," which resonates with the deeper centers in the body. They make a great contrast to the other forms and have the effect of bringing the geometric forms to life.

Before drawing your petals, you must determine whether you need one petal ring or two. The Passion, Intellect, Expansion, Bliss, Organization, Uniqueness, and Spirituality Designs all use a single ring of petals. The Radiance and Nourishment Designs require a double ring.

Single Ring of Petals

Here are the drawing instructions for creating the single petal ring.

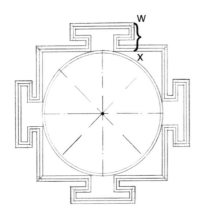

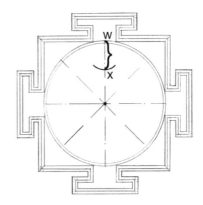

1. To find the width for the single, eight-petal ring, take your drawing of the bhupur with the outer circle and measure the distance between the top of the outer gate (w) and the innermost line of the inner gate (x) by placing your compass point on (w) and your lead on (x).

2. Using the (w)–(x) measurement obtained in step 1, place the compass point (w) at the top of the outer circle and make a horizontal mark at (x) crossing the vertical guideline.

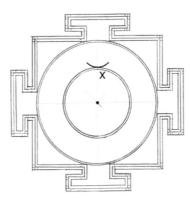

3. Place the compass point at the center of your Yantra. Open the compass, placing the lead on the new mark (x), and create your circle. To create the double line, draw another slightly smaller circle. The width of this inner circular band should match the width of the outer circle and the inner gates of the bhupur—about one-sixteenth of an inch. Now turn to the Eight Petals section on page 51 to learn how to draw your petals.

Double Ring of Petals

Here are the drawing instructions for creating the double petal ring.

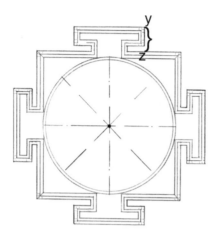

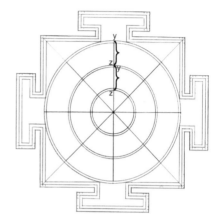

1. Take your drawing of the bhupur with the outer circle and measure the distance between the top of the outer gate (y) and the top edge of the square (z) by placing the compass point on (y) and the compass lead on (z).

2. Using the measurement (y)–(z), place the compass point (y) at the top of the outer circle and make a horizontal mark at (z) with the lead. Using the same (y)–(z) measurement, place the compass point (y) on the new marking (z) and create a second (z) marking toward the center.

 Place the compass point at the center of your Yantra. Open the compass and place the lead on the outer (z) marking; draw the circle. Draw a second, slightly smaller circle to create the double line. Keeping the compass point at the center, move the lead to the inner (z) mark; draw the circle and a slightly *larger* circle to create the double line. This inner band should be narrower than the outer two. You will now have two rings to contain the petals for your chosen design. The inner ring is narrower than the outer one. This helps create the illusion of depth.

Eight Petals

Here are the drawing instructions for filling your petal ring with eight petals.

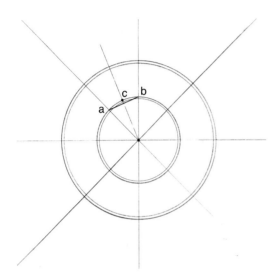

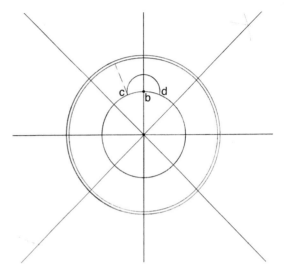

1. Divide the space (a)–(b), between the vertical and diagonal guidelines, into two equal sections. You can use your ruler to measure the halfway mark or you can bisect (a)–(b) using the compass method shown in the bhupur instructions (p. 35). The midpoint is (c). Using your ruler, draw a line from the center of the Yantra out through (c) to the edge of the outer circle.

2. Place the compass point on (b) and the lead on (c). Draw a semicircle from (c) to (d). This is your first petal guide.

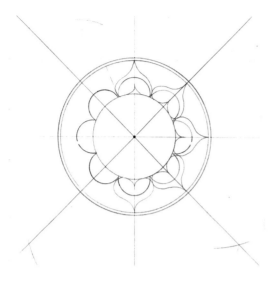

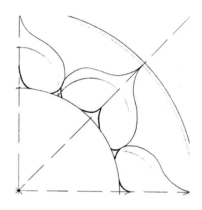

3. Placing the compass point at the intersections of the inner circular band and the horizontal, vertical, and diagonal guidelines, draw a total of eight semicircles. Allow the semicircles to touch at the base.

 Starting with the tip (where the petal will meet the outer circular band) and using the semicircle as a guide, draw your first petal. Draw all eight petals freehand with smooth, curved lines making sure that the edges of the petals touch.

4. Create lotus "seeds" at the center of each petal. Between the petals place a smaller seed-like shape.

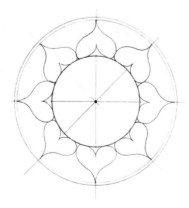

5. Erase the semicircles. Now you have your eight petals!

Twelve Petals

Here are the step-by-step instructions for creating the outer row of twelve petals found in the Radiance Design.

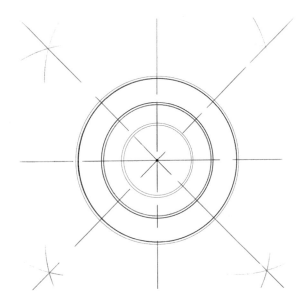

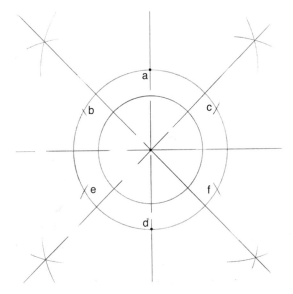

1. Take your drawing with the two rings. The twelve petals will be placed in the outer ring (between the inner line of the outer band and the outer line of the middle band).

2. Place the compass point on (a) and the lead at the indentation at the central point of the Yantra. (Note: The compass width is equal to the radius of the outer circle.) Keeping this width, with the compass point still on (a), swing the lead to the left and make a mark (b) on the inside line of the outer band. Now bring the lead to the right and make the mark at (c). Place the compass point on (d) and repeat this process—swinging the lead up to mark the outer band on either side, creating (e) and (f).

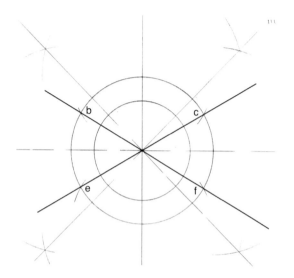

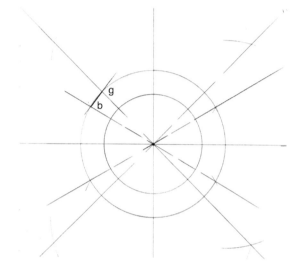

3. Using the ruler, draw a straight line connecting (b)–(f) and (c)–(e). Make sure the pencil lead passes exactly through the center of the Yantra.

4. Draw a line at the edge of the circle connecting (b) to (g), which is at the intersection of the circle and the diagonal guideline. The length of this line is the measuring unit for the twenty-four divisions needed to create the twelve petals. Place the compass point on (b) and the lead on (g), and keep the compass open at this width.

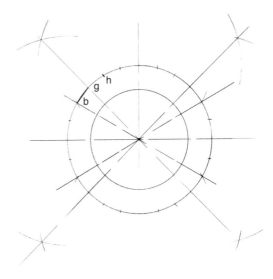

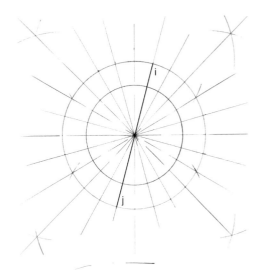

5. Using your unit of measurement, recorded with the fixed compass width in step 4, place the compass point on (g) and swing the lead to the right to mark (h). Continue, traveling in a clockwise direction, around the circumference of the outer circle marking the divisions until you reach (b) again. You will have twenty-four equally spaced marks around the edge of the circle.

6. Using your ruler, draw a line connecting (i) and (j). Continue in a clockwise direction, drawing all twenty-four guidelines. The lines will start at the point on the ring's outer circle and pass through the center of the Yantra to connect with the opposite mark. You will end up with twenty-four sections.

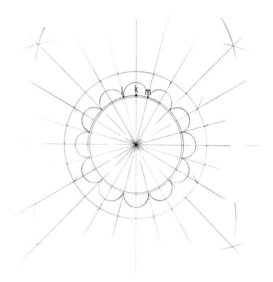

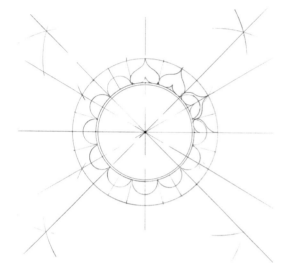

7. Place the compass point on (k) where the ring's inner circle meets the vertical guideline. Draw the first semi-circle—with endpoints (l) and (m). Continue clockwise and draw all twelve semicircles.

8. Create the twelve petals, using the semicircles as guides. Make sure the edges of the petals touch. Draw lotus "seeds" at the center of each petal and between the petals. (See detail of lotus seeds in step 4 on page 52.) Once you have drawn the petals erase the semicircular guides. Erase all extra markings, leaving visible only the original vertical, horizontal, and diagonal guidelines.

Sixteen Petals

Here are the step-by-step instructions for creating the outer row of sixteen petals found in the Nourishment Design.

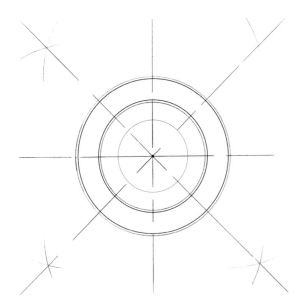

1. Take your drawing with the two rings. The sixteen petals will be placed in the outer ring (between the inner line of the outer band and the outer line of the middle band).

2. The sixteen petals are created by making small divisions within the original vertical, horizontal, and diagonal guidelines. Divide the space between (a) and (b) into two equal sections. You can use your ruler to measure the halfway mark or you can bisect (a)–(b) using the compass method shown in the bhupur instructions (p. 35). The midpoint is (c). Using your ruler, draw a line from the center of the Yantra out through (c) to the edge of the outer circle.

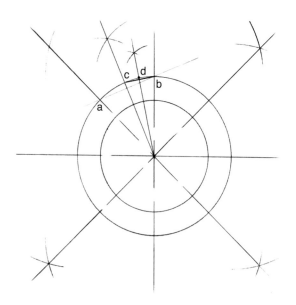

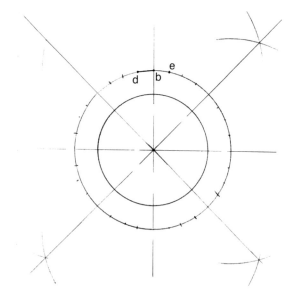

3. Repeat the previous steps to divide (c)–(b) into two equal parts. The midpoint will be (d). Draw the line from the center of the Yantra out through (d) to the edge of the outer circle. Take a moment to see that you have just divided (a) and (b) into two halves, and then divided one half of that into two sections.

4. The unit of measurement for the thirty-two divisions needed to create the sixteen petals is the space between (d) and (b). Place the compass point on (d) and the lead on (b) to capture this measurement. Keep the compass at this fixed width.

 Place the compass point on (b) and swing the lead to the right to draw the next marking (e). Continue, traveling in a clockwise direction, around the circumference of the outer circle marking the divisions until you reach (d) again. You will have thirty-two equally spaced marks around the edge of the circle.

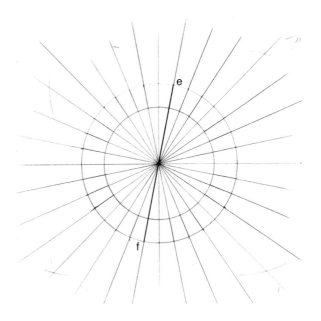

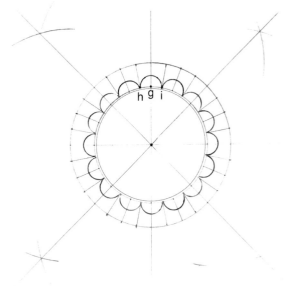

5. Using your ruler, draw a line connecting (e) and (f). Continue in a clockwise direction, drawing all thirty-two guidelines. The lines will start at the point on the ring's outer circle and pass through the center of the Yantra to connect with the opposite mark. You will end up with thirty-two sections.

6. Place the compass point on (g) where the ring's inner circle meets the vertical guideline. Draw the first semi-circle—with endpoints (h) and (i). Continue clockwise and draw all sixteen semicircles.

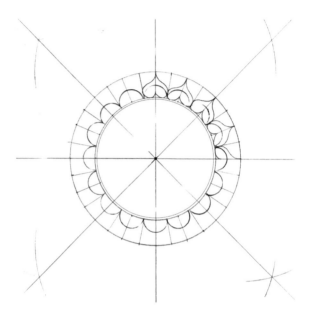

7. Create the sixteen petals, using the semicircles as
 guides. Make sure the edges of the petals touch. Draw
 the lotus "seeds" at the center of each petal and
 between the petals. (See detail of lotus seeds in step 4
 on page 52.) Once you have drawn the petals erase
 the semi-circular guides. Erase all extra lines, leaving
 visible only the original vertical, horizontal, and diago-
 nal guidelines.

Triangle

Pointing either upward or downward, the triangle is the most dynamic geometric form. The energized upward-pointing triangle connects with masculine forcefulness. It is said to direct one's energy to the higher realms. It represents the element of fire and the powerful forces of transformation. The downward-pointing triangle is a more receptive form—drawing energy to the earth, connecting with feminine qualities, and facilitating access to creativity. It represents the element of water and the ability to trust the intuitive impulses of Mother Nature. The next shape that we will learn about, the six-pointed star, combines the upward- and downward-pointing triangles.

The triangle is symbolic of the trinity, which plays a significant role in many spiritual traditions. For example: the creator, preserver, and destroyer; the father, son, and Holy Spirit; the manifest, unmanifest, and the human being who contains both. Within sacred geometry, the triangle is the third element after the circle and the square. In Zen Buddhism these three forms symbolize the unity of creation. In each individual the qualities of activity, rest, and harmony need to be in their rightful balance for good health to be present.

I find that working with the triangular form centers me and gives me an additional source of strength and energy. The point of the triangle is like an arrow pointing me toward my best—whether completing a project or fulfilling the task at hand to the best of my ability. The triangle creates a strong pull on the mind, directing it to the focal point at the center of the triangle, which in turn guides the mind to rest on the center within. This reflective action of meditating on an external form to create an internal effect is at the heart of working with the sacred Yantra.

The triangle is the dominant shape in the Passion Design, which harnesses the power of the triangle and uses it to connect with, and direct your mind toward, that which has passion and meaning for you. This design teaches you more about the qualities of the triangle and the powers that the form imparts.

Composed of precisely placed straight lines, the triangle is a compelling shape to work with. By creating the form you will begin to notice a clarity and precision coming to life within you. Your drawing meditation can begin by arranging the tools you use to create the triangle: pencil, compass, and ruler. Keep the pencil sharp, the lead in the compass with a fine point, and the ruler's sides crisply clean. Make sure you have good light to see that the lines meet precisely.

DESIGN NOTES

Begin by taking long, deep breaths as you draw your first triangle. This will enable you to reach a place of dynamic clarity that the shape will beautifully mirror back to you. Fuzzy and mismatched lines will fall away as your thinking quiets and you become "one-pointed" in the present moment. The points of the triangle's corners and the point of the lead all bring a crispness to the practice, allowing you to become decisive and clear. When all the lines meet each other equally, the form is exquisitely beautiful.

An upward-pointing equilateral triangle with twenty-one inner triangles is found in the Passion Design.

Upward-Pointing Equilateral Triangle

Here are the step-by-step instructions for creating the upward-pointing equilateral triangle.

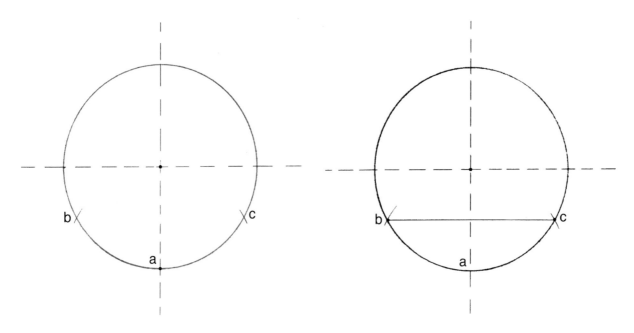

1. Take your Yantra drawing with the ring of eight petals. Open the compass to the radius of the innermost circle of the petal ring—from the center to (a). Place the compass point on (a) and swing the lead across the circle on either side, marking the two places where the lead and circle meet (b) and (c).

2. Take the ruler and draw the horizontal line connecting (b) and (c).

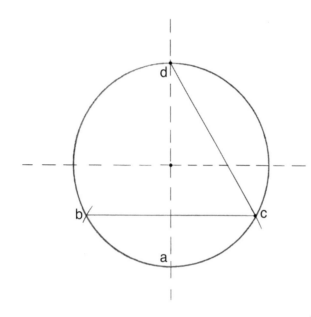

3. Connect (c) and (d).

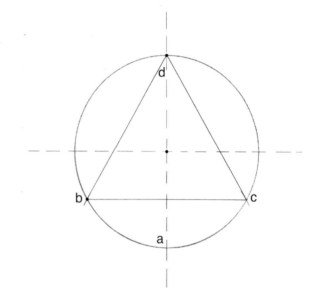

4. Connect (b) and (d). You now have your upward-pointing triangle.

Inner Triangles

Here are the step-by-step instructions for creating the inner triangles found within the upward-pointing equilateral triangle in the Passion Design. Note: Draw all lines with a ruler and a sharp pencil lead to keep lines clean and crisp.

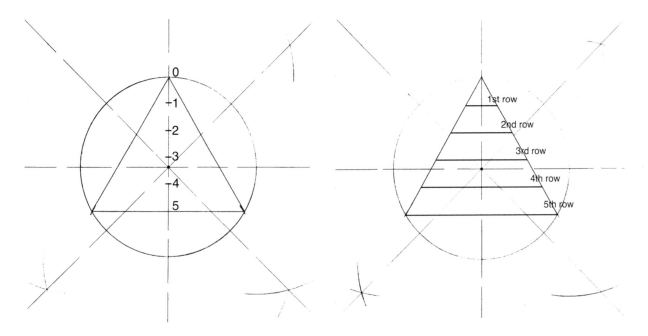

1. Divide the height of the triangle into five equal sections (0–5) on the vertical line. You can use a calculator and ruler to make these precise divisions.

2. Draw four horizontal lines across the triangle through the central markings 1–4 of step 1, creating five rows.

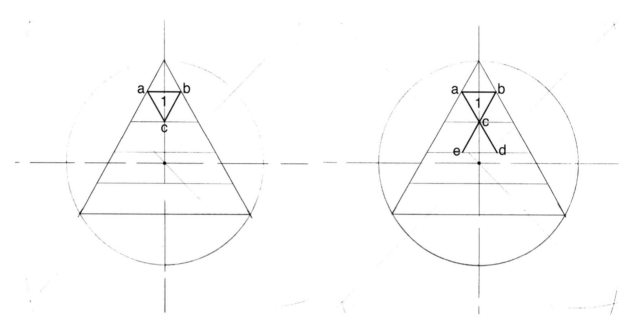

3. Draw the first downward-pointing triangle on the second row by tracing over the horizontal line (a)–(b) and connecting (a)–(c) and (b)–(c).

4. To locate points (d) and (e) and connect them to the midpoint (c), place your ruler on the existing line (a)–(c) and extend the line down to the next horizontal line to create point (d). Extend line (b)–(c) to create (e) on the horizontal line.

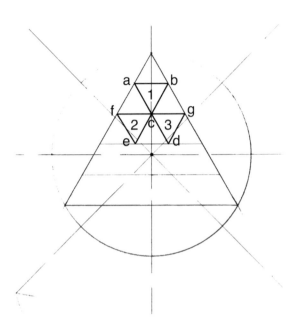

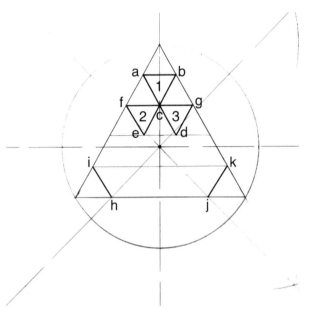

5. To create the downward-pointing triangles 2 and 3 on the third row, trace over the horizontal line (f)–(g). Connect (f)–(e) and (g)–(d).

6. Connect the points on the lower corners of the large triangle (h)–(i) and (j)–(k). Points (h) and (j) are placed where the diagonal guidelines intersect the base of the triangle.

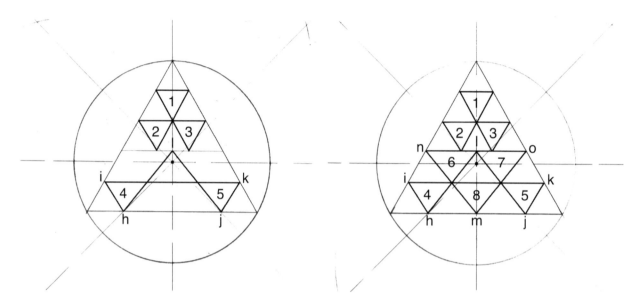

7. Connect (h)–(l) and (l)–(j). Point (l) is located where the bottom of row three intersects the vertical guideline. Trace over the horizontal line (i)–(k). This creates the downward-pointing triangles 4 and 5.

8. Connect (n)–(m) and (m)–(o). Point (m) is located where the vertical guideline intersects the base of the triangle. Trace over the horizontal line (n)–(o). You have just created the downward-pointing triangles 6, 7, and 8. You will now have eight downward-pointing and thirteen upward-pointing triangles within the larger triangle.

Six-Pointed Star

The six-pointed star is a powerful spiritual symbol, found in many traditions around the globe. In Egypt it has been found in hieroglyphics as the ancient seal of Solomon. It can be seen in Judaism as the Star of David and in Hinduism as the divine union of Shiva/Shakti. To the tantrics of ancient India this divine union symbolize the joining of the opposing forces of spirit and the earthly realms. The six-pointed star locates us between heaven and earth, form and formlessness, upward and downward, masculine and feminine energies. As humans we are constantly pulled between these energies, and this star brings us back to the center. This is a physical and spiritual experience centered in the physicality of our being. It is rather like finding yourself at the eye of the hurricane, with the movement all around you, and yet being drawn inward to the stillness of the center. It is clear to see how the outer diagram, the shape of the star, beautifully reflects the inner journey.

The word *yoga* literally means "union with the divine self." The six-pointed star is a powerful yogic symbol. The upward-pointing triangle represents the dynamic male energy known as Shiva—the formless; this is pure movement. The downward-pointing triangle represents the feminine energy known as Shakti—potential energy as form. It takes the movement of Shiva to ignite the power of Shakti to create a dynamic dance or union of these opposites and bring the formless to life.

The intersection of two geometric forms can represent forces that are more intense than those generated by a single form. A Yantra is a powerful image because of this fact and the six-pointed star, which appears in seven of the Nine Designs, is a symbol that contains immense focusing power. I like the way this form surrounds the central point, the bindu, in the Yantra. The star creates an even space above and below the bindu for the gaze to be brought with comfort to the center of the design. When meditating upon the final image, one's gaze bounces back and forth within the six-pointed star to perpetually rest at the center. The six points give the illusion of expansion in all directions and yet ultimately the observer's eye rests not away from, but toward, the center.

In the Yantras, the juxtaposition of the color within the star and the color behind it creates one of the most satisfying color relationships and becomes the poignant focal point of the design. From this color relationship the gaze can travel out to incorporate all of the colors in the Yantra or zero in on the center where it finds its home in the gold bindu.

A seemingly simple symbol, the six-pointed star carries with it a guiding light to lead you into the wonders of working with Yantras like no other one form.

DESIGN NOTES

The six-pointed star takes the basic shape of the triangle and reproduces it in its inverted position. This completely changes the feeling that comes from the triangular symbol. The downward-pointing form offers a softer compliment to the upward-pointing triangle and the whole form appears—despite its pointed edges—to be full, soft, and circlelike. It is pleasing to the gaze when the lines of the star are not too thick. These potent direction lines are most compelling when clear and well defined.

The six-pointed star sits within the inner circle. The size of the circle will vary according to the petal designs for your chosen Yantra.

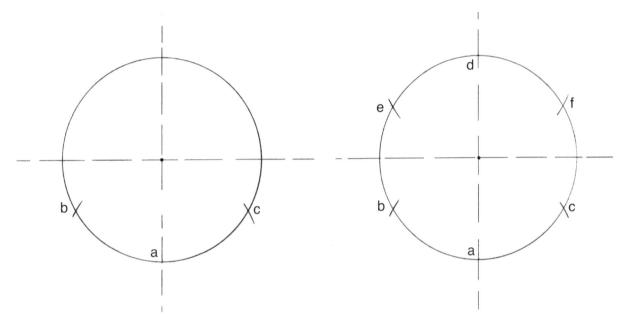

1. Take your Yantra drawing with the ring(s) of petals. Open the compass to the radius of the innermost circle of the innermost petal band—from the center to (a). Place the compass point on (a) and swing the lead across the circle on either side, marking the two places where the lead and circle meet (b) and (c).

2. Keep the compass at the fixed width used in step 1 and place the compass point on (d) at the top of the circle. Swing the compass down across the circle on either side, creating the marks (e) and (f).

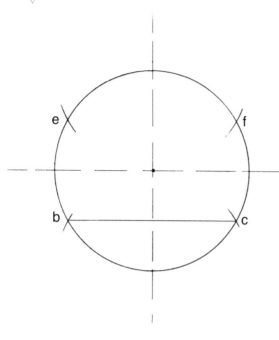

3. Using the ruler, draw a straight line connecting (b) and (c).

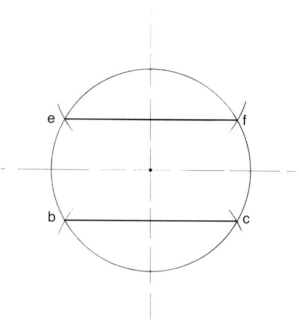

4. Draw a second horizontal line connecting (e) and (f).

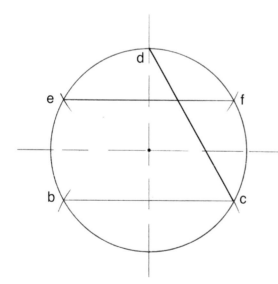

5. Connect (c) and (d).

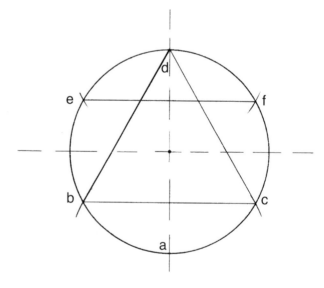

6. Connect (b) and (d). You will now see the upward-pointing triangle.

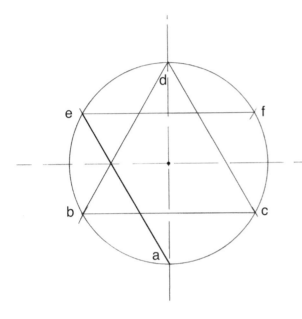

7. Connect (e) and (a).

8. Connect (a) and (f). You just created the downward-pointing triangle, completing the six-pointed star.

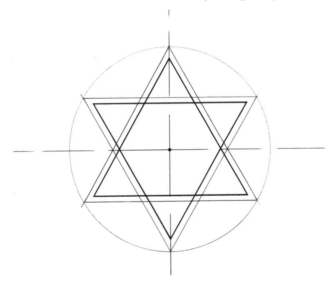

9. To make the double line, draw a second line on the inside of the star. The width between these double lines should be approximately one-sixteenth of an inch—slightly less for the Radiance and Nourishment Designs.

Square

The square is one of the fundamental building blocks of the Yantra. The bhupur—which houses the circle—is based on a square. This presents the juxtaposition of form and formlessness. The square is the finite form that contains the infinite forms such as the circle and the central point. The square is the foundation—a symbol of stability. As a whole, it contains the sweetness of the earth; individually, each side represents one of the four elements that make up the physical world (earth, water, fire, and air). The square symbolizes creation in matter, representing all that is tangible in form. It serves as a container for the subtle energies that underlie all of creation—giving the spirit a form through which it may be perceived and experienced.

The lines of a square are of equal length giving it a stabilizing force. In sacred geometry, the square represents the physical world. It can be defined totally: if its side is one, its perimeter is four, and its area is one square—exactly. The symmetry of the form is harmonizing to the viewer and to the many other shapes around it.

Each side of the square defines one of the four directions—north, south, east, and west. This anchors the Yantra in time and space, again making it available for the formless, timeless energies to emerge. The connecting points of the square, the corners, signify northeast, southeast, southwest, and northwest. The square and its three-dimensional form, the cube, are primary forms, foundational building blocks. We're perhaps more familiar with the square than with any other shape, because it permeates our lives in practically everything that we build or make. The square is our ally when we need to build firm foundations. You can build a lot of things on a solid, square base. It is a square at the base that gives rise to the auspicious, elevated form of the pyramid.

In working with sacred space, the important aspect of the square is the diagonal. If the square has sides of 1 unit in length, then the length of the diagonal is the square root of 2 (1.41421 . . .). You can easily prove this for yourself using the Pythagorean theorem. The square root of 2 is an irrational number. Stand in the center of the square and you stand at the center of two theoretically infinite lines. A classical example of this was the Holy of Holies in Solomon's Temple. It was forbidden to enter into this space where they kept the ark. A more contemporary incarnation is the Kaaba in Mecca.

I find that the process of drawing a square gives me repeated opportunities to connect with and become familiar with the horizontal and vertical lines in the Yantra. The horizontal line suggests the horizon—the calm, infinite space across—while the vertical line connects to gravity and the gravitational pull from the sky to the earth. You can notice these two lines in your life: in the physical body the horizon suggests relaxation and expansion (movements such as lying down on the ground or relaxing the belly) and the vertical line represents grounding, finding your relationship to gravity, and lengthening the spine.

DESIGN NOTES

The square is found within the Bliss Design, interlaced with a second square at a 90° angle. The second square appears as a diamond, giving the forms a feeling of spinning. The pair creates what is known as a dynamic square. The six pairs of interlacing squares in the Bliss Yantra offer the viewer the appearance of spinning backward into infinity. The static squares give the eyes a calm line to rest upon while the offset "diamond" squares allow the eyes to travel backward with depth into the Yantra. The Bliss Design embodies the journey of meditation where you can go deeper and deeper into the peaceful space within. It is one of my favorite designs to have in my home—soothing and reminding me that the "goals" that we so often think are "out there" are more often within.

Drawing the sets of squares is an interesting experience, requiring great precision. The squares' 90° corners combine to create 360° forms with true horizontals and verticals. The methodical drawing of this design relies on patience and focus yet ultimately leads to a timeless, out-of-focus vision, appearing to transcend the two dimensions of the paper. There is something satisfying about creating this true, precisely balanced form.

The step-by-step instructions for creating the interlacing squares in the center of the Bliss Design are found on the following pages.

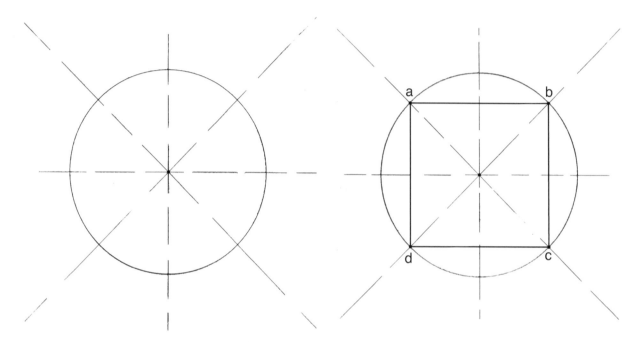

1. The inner circle within the ring of petals will contain the six pairs of interlacing squares. These squares will rest on the vertical, horizontal, and diagonal guidelines, so make sure that these lines are still clearly visible.

2. Create the first square by connecting the intersecting points where the diagonal guidelines meet the circle: (a)–(b), (b)–(c), (c)–(d), and (d)–(a).

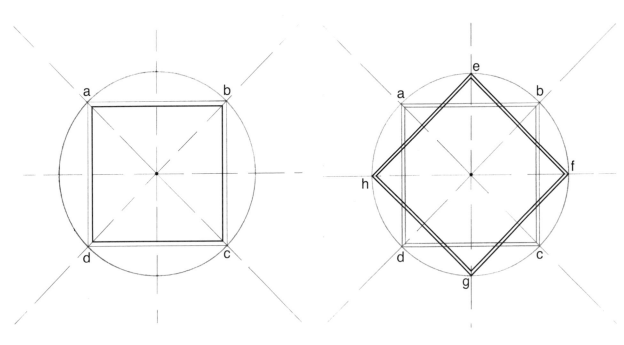

3. Draw a second line just inside the first to create a double line (a little less than one-sixteenth of an inch wide).

4. To draw the first square that is oriented on the diagonal (the "diamond" square), connect the intersecting points where the outer circle meets the horizontal and vertical guidelines. This creates the lines (e)–(f), (f)–(g), (g)–(h), and (h)–(e). Draw the second line just inside your new square to create the double line. You now have your first set of interlacing squares.

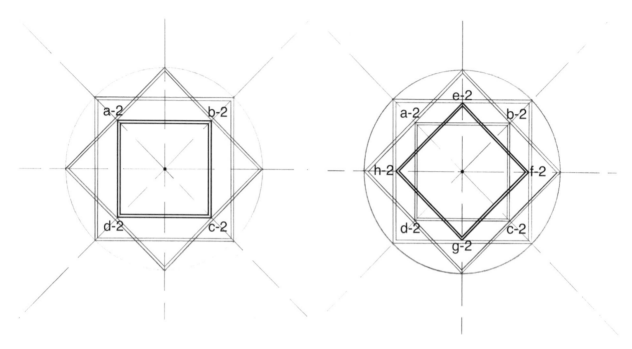

5. To create the second square oriented on the vertical and horizontal guidelines, connect (a-2) and (b-2), (b-2) and (c-2), (c-2) and (d-2), and (d-2) and (a-2). These are the points where the diagonal square you drew in step 4 intersect the diagonal guidelines. Draw the second line just inside your new square to create the double line.

6. Draw the second diagonal square by connecting (e-2) and (f-2), (f-2) and (g-2), (g-2) and (h-2), and (h-2) and (e-2). These are the intersecting points of the first square with the vertical and horizontal guidelines. Draw the second, inner line to create the double line. You now have two sets of interlacing squares.

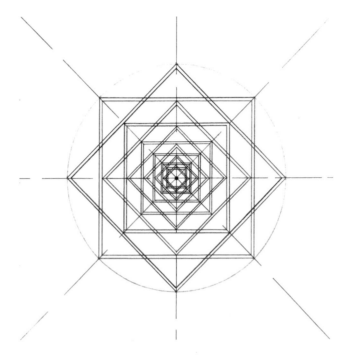

7. Continue in this way, creating four more sets of squares for a total of six. Drawing the double lines closer together the nearer you are to the center helps to give the Yantra the illusion of depth.

Bindu

The tiniest circular form (a dot), known as the *bindu,* resides at the center of each Yantra. It is the main focal point in the Yantra—each of the other geometric components guides the viewer's eye toward the central point of the bindu.

The bindu is known as the seed or the essence of creation. This is the first drop of divine nectar, which spreads, unfolds, and expands into the tangible realm of the universe. The bindu also represents the all-pervading, birthless, formless, deathless supreme consciousness.

There is a beautiful metaphor in the ancient Hindu text, the Brhadaranyaka Upanishad, of a spider sitting at the center of its web, emitting its threads in concentric circles, all held at one point. The spider's threads expand out into the circumference symmetrically, but they can all be traced back to the central point of the web. Like the spider in its web, the center of the Yantra is the visual source of the energy that expands to create all of the forms within the sacred diagram.

Also referred to as the zero point, the bindu is the symbol of no-thing. It is the point that contains infinite possibilities. Although it contains no tangible qualities of its own, it can catalyze the essence of the deity into form. As such, the bindu can be seen as the void, or the field of pure potentiality. It is the emptiness of the void that gives rise to the experience of the bliss of pure being.

The bindu is also seen in the OM symbol, ॐ, the primordial sign representing the entire universe. The bindu signifies the silence into which the sound of OM leads. When we are fully absorbed in that silence, it becomes a magnet for our attention and concentration, creating the ideal condition for the realization and knowing of the limitless peace within.

As you can see, the bindu, despite its deceptively small size, is of great significance within tantric mysticism. In fact, on a mystical level it can be seen as the point of union of the male (Shiva) and female (Shakti) energies of creation. When the Yantra is gazed at in meditation, the bindu is the region where the sacred union of the viewer and the Divine takes place.

In one of the great scriptures known as the Shakta Tantras, where the primal energy is worshipped in the form of Divine Mother Goddess, the Absolute desires to become many and starts reflecting on itself. This movement, which begins as vibration, gets concentrated to a point, or bindu. The bindu, seen again as a seed—of the

Shiva/Shakti (male/female) principle in one closely knit unit—gradually swells, giving rise to the polarization of Shiva (the father principle) and Shakti (the mother principle), while retaining the potent Shiva/Shakti combination. These three units now form a triangle, and the process goes on to produce the entire Yantra. The metaphor here from the bindu within the Yantra is the representation of the supreme consciousness in its various levels of evolution.

DESIGN NOTES

Drawing and coloring the bindu is like arriving at the summit of the mountain you have just climbed. It is a moment to savor, to pause, to recommit or to state your intention for creating your chosen Yantra. Once you have drawn the bindu, stop and contemplate how that one action, the final circle, has brought the whole design into a magical dimension. When you are at the coloring stage, before applying the paint or the colored pencil, pause; take a couple of deep, slow breaths and recite the mantra. As the focal point of the Yantra, the finishing touch of the bindu deserves a special, almost ceremonious, approach, concluding this already rich and mindful experience.

The center of the Yantra has served as a reference point throughout the construction of the Yantra and is the last element you will color. It is the point of both creation and completion.

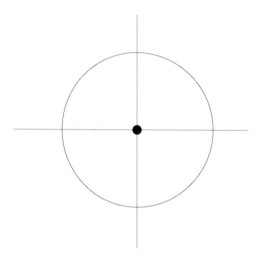

1. By now you will have a strong indentation at the center of your Yantra from the compass point. This indentation denotes the bindu's placement. By hand create a small circle around the compass point indentation. If you are working on a large scale, you can use a compass to draw this circle.

Coloring the Bindu

Once the Yantra is colored and you are ready to complete it, color the bindu—filling in the small circular shape around the compass indentation—using either gold paint or a strong brown colored pencil or crayon. If you are painting, fill in the bindu with a few layers of gold paint using a paintbrush with a good point. You can try to fill the hole with paint and even create a slightly raised surface on the bindu. If you are coloring, create a strong and compelling central form by applying a good layer of pencil or crayon color on the bindu.

At this stage, once the coloring is completed, you can erase the OM from the top of your Yantra. On the back of the paper, write the mantra for your design at the top. This will indicate the correct orientation without visually distracting from the design, and the words of the mantra will enhance the power of your Yantra.

4 Recipes for the Nine Designs

Now that you have chosen your design and learned about the materials you will need as well as the layers of steps that go into creating the shapes, you are ready to put it all together and create your Yantra. You can refer back to The Nine Designs page in chapter 1 (p. 18) for the page number on which the section for your chosen design begins. The recipes have been tried and tested and it is best to begin by following the instructions carefully and methodically. Yet just as in cooking your favorite dish, the recipe is but a springboard for you to step into your personal creation.

For each Yantra, a full-page color image is provided to give you a picture of the finished design. Again, your Yantra will not look exactly like mine, just as your dish will not taste just the same as mine. Even with identical recipes, our personalities do flavor and color the outcome. The full-page hand-drawn outlines are provided to give you a sense of what your design will look like before you apply color. This is helpful to refer to as you go through the drawing stages. If you choose to color in a completed Yantra outline, make your copies from those provided in the appendix. The crisp lines of those outlines will reproduce beautifully.

For each design, the corresponding mantra is provided along with a phonetic spelling indicating the correct pronunciation. Please note that AI (which is also found in JAI and YAI) is pronounced so that it rhymes with the word *eye*.

Om Sum Suryaya Namaha

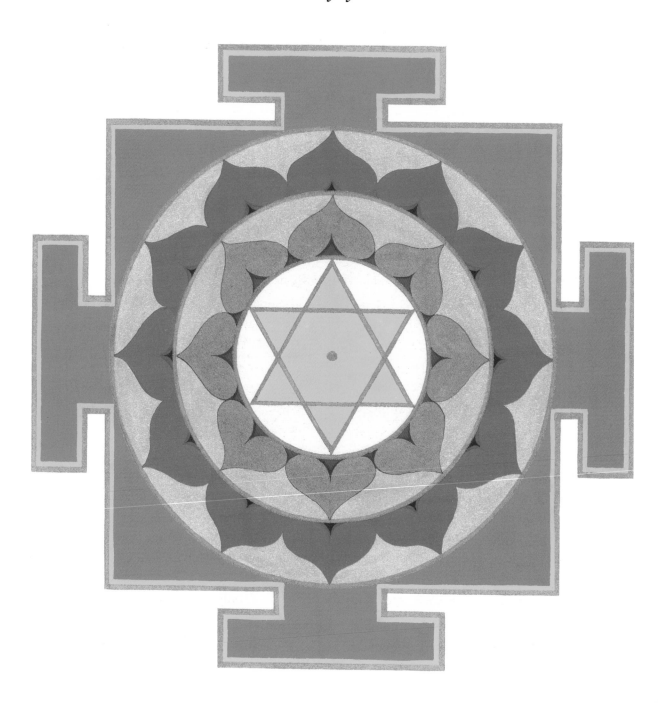

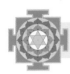

Radiance

The first of the Nine Designs is Radiance. This Yantra, which invokes the vitality of the life force, is a great beginning point. Without the wealth of spirit the Radiance Design awakens, life's riches can seem both daunting and dull. Radiance is colored with bright yellows, oranges, and reds to represent the warmth of the Sun; these are offset by the pale blue color at the center, representing the sky.

The Radiance Design has a distinct outer ring of twelve petals, which signifies the twelve celestial beams emanating from the Sun. Shining equally on all beings, the radiant beams represent the divine light within each person. Radiance awakens spiritual awareness and an ability to know one's purpose in life, bestowing strength, endurance, and clarity upon one's sense of self. The Sun is the father of the solar system, denoting qualities of integrity, honor, and respect.

Just as orange reminds us of the Sun, it also invokes energy and magnetism. Orange inspires a warmhearted welcoming response to those it touches and offers a liberal open-minded spirit to all it shines upon. By nature it is independent and self-reliant, yet those touched by the color light up in the company of groups and in social situations. This boosts one's sociability, making it fun to go out and entertain friends or current company. Prosperity and success are the natural outcomes of this revealed brilliance and self-confidence. Orange gives great vitality and generates movement and activity. It is a creative color. Shyness and self-doubt are dispelled by orange, allowing one to express oneself without inhibition or self-consciousness. Creativity in all its forms is a natural, joyful outcome of this liberating color.

The gemstone that inspires the colors within this design is the ruby. This clear, smooth stone contains a light-giving quality. The ruby appears in a range of colors from pink to deep violet. The outer petals of the Radiance Design capture the red of this stone.

I like to work with the Radiance Design when I feel overwhelmed by too many tasks. This Yantra allows me to rise up and with bright optimism see easy and skillful solutions. It helps me find ways to delegate specific tasks successfully. It reminds me that within each of us there is a greater life force at work—if only we can get out of the way and let it come through.

The twelve petals of the Radiance Design also relate to the twelve signs of the zodiac. Understanding these twelve distinct astrological phases or personalities, each

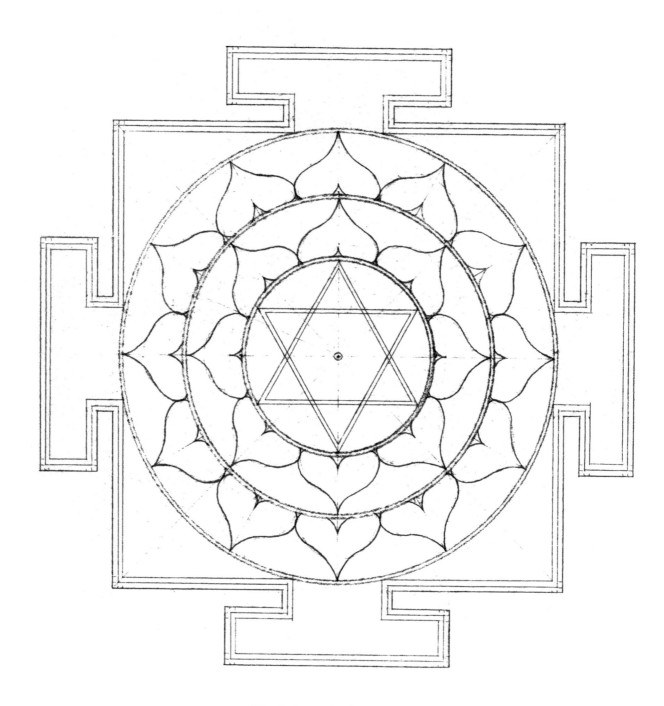

Hand-drawn Radiance Design

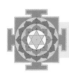

wonderful in its uniqueness, encourages a great acceptance of each person's special path in life. Just as many distinct petals combine to create one flower, each person has his or her own way of living that contributes to the whole of society. The flower, just like life itself, remains rich and beautiful due to these colorations. The liberal quality denoted by this Yantra extends to cultivate an appreciation of the diversity within the unity of creation. If you are feeling torn or divided by difference, or requiring a boost of self-confidence, this will be a good Yantra to work with.

The sound vibration for Radiance is:

Om Sum Suryaya Namaha

(OM SOOM SOOR-YAI-YAH NAHM-AH-HA)

This means: I honor the Radiance within.

By repeating this sound (either externally or internally) while working with the visual Yantra, a profound and personal experience of inner radiance will awaken within.

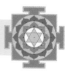

Radiance Recipe

MANTRA

Om Sum Suryaya Namaha

THE SHAPES

Bhupur (p. 32) Six-pointed star (p. 69)

Circle (p. 44) Bindu (p. 80)

Petals (p. 47)

ASSEMBLING THE SHAPES

1. Construct the bhupur outline and make the inner gates (p. 34)

2. Draw the outer circle (p. 46)

3. Create two circular bands to contain the double petal rings (p. 50)

4. Construct the twelve outer petals (p. 53)

5. Draw the eight inner petals (p. 51)

6. Follow the steps for drawing the six-pointed star (p. 71)

7. Finally, place the bindu at the center (p. 82)

8. Erase all guidelines and extra markings

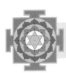

DESIGN NOTES

The dynamism in the Radiance Yantra comes from the play of the two rows of petals: the outer ring has twelve petals and the inner ring has the eight-petal formation seen in most of the Yantras. As you work with these forms, you will see how the many subtle correspondences between the shapes provide a seamless structure. I love this design. It requires much concentration with the initial mapping out of the petals; yet once it is drawn and colored its vivid richness generates a stimulating response.

COLOR

Colored pencils: A range of warm reds, oranges, and yellows, cool pale blue, gold (or light brown), and silver (or gray).

Gouache paints: Scarlet lake, spectrum red, golden yellow, lemon yellow, cerulean blue, permanent white, gold, and silver.

COLOR NOTES

The outermost band of the bhupur (the outer gate) is gold; the inner gate is deep golden yellow. Red, orange, and yellow colors in this design are offset by the pale blue and silver background areas. The twelve petals are bright orange-red and the eight inner petals are a glistening gold color. Both rings of petals contain deep red lotus seeds at their center. Think sunny and radiant! Use the color image on page 84 to guide you.

Om Cham Chandraya Namaha

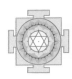

Nourishment

The Nourishment Design is a shimmering pearl-like image with hues of pastel blue and mauve. The design soothes and nurtures the emotions and directly influences the physical body, the mind, and the spirit. Just as the emotions, are changeable, this design too appears altered with each new perspective. Silver dominates this Yantra giving it a highly reflective surface, which makes it appear greatly changed when viewed at different angles.

The nurturing Moon inspires this design. The Yantra's outer ring of sixteen petals signifies the sixteen celestial beams emanating from the Moon. As the mother of the planets, the Moon signifies the feminine principle, compassion, receptivity, and sensitivity. The pastel blue and mauve colors of the Nourishment Design promote these qualities and have a strong influence on spiritual healing.

The Moon also governs water, the tides, and developing harmony with the natural rhythms and cycles in one's life. Having compassion for others starts with nurturing and listening to oneself. This is the perfect Yantra to work with in situations involving self-destructive behaviors or emotionally reactive episodes. By calming down and getting in touch with the emotions as they arise, great insight, compassion, wisdom, and right action result. As this connects with mother energy and the Divine Feminine, relationships with one's femininity, mother, or other women in one's life will improve, and there will be deeper levels of understanding and appreciation of them.

The feminine is also seen as an intuitive force in our lives. Intuition and receptivity can be developed by working with this Yantra. Imagination and creativity flow from these new levels of insight. It can be helpful to explore storytelling and myths when working with the Nourishment Design to access imagination and insight.

The gemstone that inspires the colors within this design is the pearl. The pearl contains a Moonlike, shining white color. It reflects light from its surface, sending iridescent colored rays out from it. The pearl is attractive and has a reflective brightness. The fullness of its circular form and its high specific gravity breed contentment. This is the contentment that gives self-assurance, just as a mother's love nourishes and fulfills the child. Unconditional love is seen in the fullness of the circular form, whole and complete. Devotional practices such as heartfelt singing are an excellent way to tap into this energy.

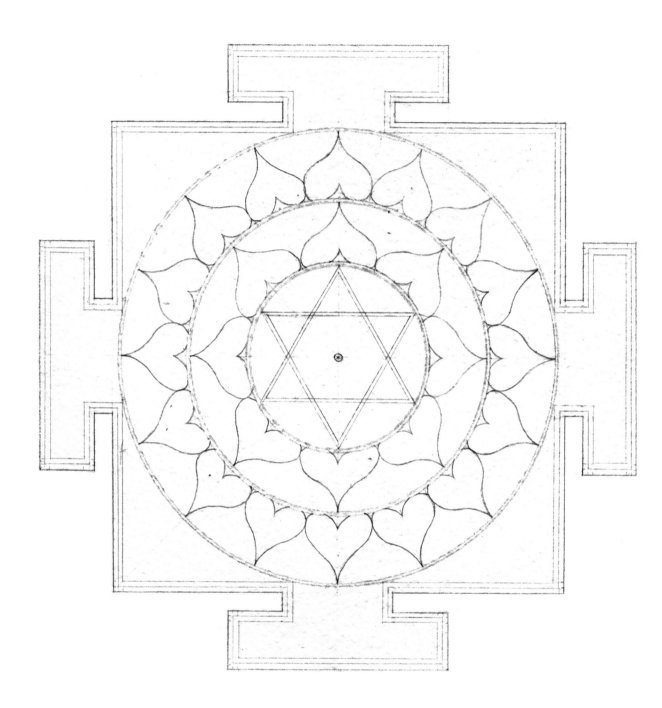

Hand-drawn Nourishment Design

Working with the Nourishment Design softens my rational mind and brings me into the place of the heart where I can surrender to things being as they are. In this space I am available to new ideas, to letting results come to me rather than feeling I have to fight for them. The pressure is off and I surrender. It is a wonderful feeling. This is a good Yantra for developing self-love and acceptance.

The sound vibration for Nourishment is:

Om Cham Chandraya Namaha
(OM CHAHM CHAHN-DRY-YAH NAHM-AH-HA)

This means: I honor the quality of nourishment within.

By repeating this sound (either externally or internally) while working with the visual Yantra, a new experience of self-healing and nourishment will take place.

Nourishment Recipe

MANTRA

Om Cham Chandraya Namaha

THE SHAPES

Bhupur (p. 32) Six-pointed star (p. 69)

Circle (p. 44) Bindu (p. 80)

Petals (p. 47)

ASSEMBLING THE SHAPES

1. Construct the bhupur and make the inner gates (p. 34)

2. Draw the outer circle (p. 46)

3. Create two circular bands to contain the double petal rings (p. 50)

4. Construct the sixteen outer petals (p.57)

5. Draw the eight inner petals (p. 51)

6. Follow the steps for the six-pointed star (p. 71)

7. Finally, place the bindu at the center (p. 82)

8. Erase all guidelines and extra markings

DESIGN NOTES

The peaceful shimmering in the Nourishment Yantra comes from the pastel colors juxtaposed with the silver sections. The sixteen petals in the outer ring is double the number of petals in the inner ring, giving the feeling of symmetry, beauty, and harmony as the gaze is guided inward. This healing design is both soothing to create and to gaze at upon its completion. The circle is a dominant symbol for the Nourishment Design. The gold bands defining the two rings of petals contrast with the silver and lighter colors to give the circular forms great presence.

COLOR

Colored pencils: A range of pastel blues, mauve, light yellow, white, gold (or light
 brown), and silver (or gray).
Gouache paints: Cerulean blue, magenta, lemon yellow, permanent white, gold, and
 silver.

COLOR NOTES

The bhupur's outer gate is gold; the inner gate is lemon yellow. Pastel blue and mauve colors are placed next to silver and white surfaces in this design to create a shimmering effect. The sixteen outer petals are silver and the eight inner petals are a lighter shade of the bhupur's blue. Both sets of petals have blue lotus seed centers. Use the color image on page 90 to guide you.

Om Kum Kujaya Namaha

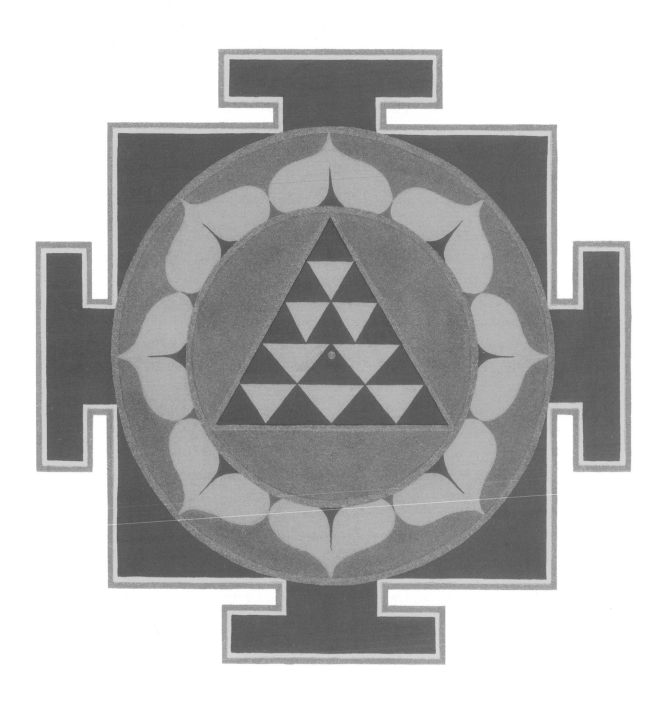

Passion

The Passion Design is a visually dynamic image due to the vivid reds within the many triangular forms. Triangles denote one-pointed action. Working with this design will help cultivate focus and drive. The courage needed to fulfill ambitions and the will to succeed are spurred by the Passion Design.

Passion itself is aroused through this design. Passion of a sexual nature is heightened. A strong sexual impulse is usually seen as the masculine drive, but here it is also seen in the strong force of Mother Nature. The vibrancy of the reds make one glowing and attractive.

The Passion Design is associated with the fiery planet Mars. Mars is seen in the sky as an awesome, red presence. The energy of Mars inspires self-confidence, independence, and the ability to achieve goals with passion and conviction. These goals can be well-defined and the action taken to achieve them will be unwavering and doubt-free. If you are having trouble focusing on, or even naming your goals and passions, this design is for you. You will also find it helpful if you are easily distracted or a procrastinator—the Passion Design is the great motivator.

The influence of Mars also makes the Passion Design helpful in defending a position, such as a social or political stance. Martial arts and the warrior energy can be used to win personal or societal conflicts.

The Passion Design contains the upward-pointing triangle—representing the masculine energy of action and growth—as the dominant shape. This large triangle contains five rows of smaller triangles that point both upward and downward, bringing balance to the form. The tiny upward-pointing triangles are a darker red, giving them a stronger presence.

The gemstone that inspires the colors within this design is coral. Coral is a fascinating substance, formed from iron oxide calcium deposits, and found in the ocean in coral reefs. Coral exists in a variety of colors, but most prominent are the many shades of pink and red. The coral gemstones emit a vitality that resonates with this Yantra.

I often create the Passion Design when I am presented with choices. Too often, external influences manipulate our decision-making and hinder our ability to listen to our inner truth. The independence inspired by this design helps access thoughts, feelings, and concerns, while the energy of the Passion Design gives us the confidence

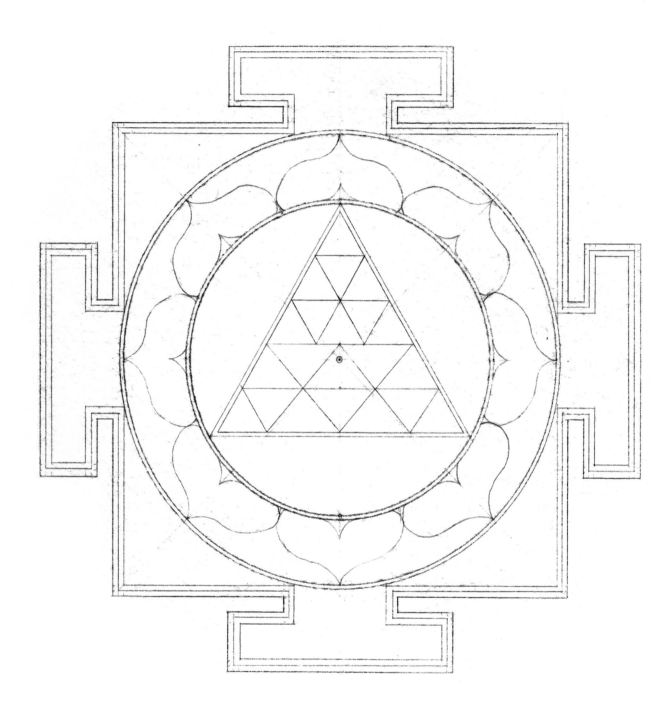

Hand-drawn Passion Design

to voice those feelings and follow through with their full expression. Because it also represents physical vitality and strength, you will benefit from this Yantra if you need the mental, emotional, and physical stamina to see your projects through to completion. By harnessing your willpower great feats can be achieved.

The sound vibration for Passion is:

Om Kum Kujaya Namaha
(OM KOOM KOO-JAI-YAH NAHM-AH-HA)

This means: I honor the passionate energy within.

By repeating this sound (either externally or internally) while working with the visual Yantra, a new experience of strength, vitality, and passion will take place.

Passion Recipe

MANTRA

Om Kum Kujaya Namaha

THE SHAPES

Bhupur (p. 32) Triangle (p. 61)

Circle (p. 44) Bindu (p. 80)

Petals (p. 47)

ASSEMBLING THE SHAPES

1. Construct the bhupur and make the inner gates (p. 34)

2. Draw the outer circle (p. 46)

3. Create one circular band to contain the petal ring (p. 49)

4. Draw the eight petals (p. 51)

5. Create the large upward pointing triangle (p. 63)

6. Draw the inner triangles (p. 65)

7. Finally, place the bindu at the center (p. 82)

8. Erase all guidelines and extra markings

DESIGN NOTES

The vibrancy of the Passion Design comes from the strong triangular forms defined by the shades of red. The upward-pointing triangle is the prominent shape within this design and is echoed by the tiny triangles in the center. While gazing at the triangles, one's energy is directed upward. The triangles should be drawn and colored with a fine point to keep the "brightness" of the forms. The cooling, silver color found in most Yantras is replaced here by the warming, reddish bronze—giving this Yantra an uplifting and arousing feel. The large areas of bronze color produce a deep reflective surface reminiscent of large copper vessels—strong and resilient.

COLOR

Colored pencils: A range of bright reds and pinks, deep yellow, bronze (rust), gold (or light brown), and silver (or gray).

Gouache paints: Spectrum red, rose tyrien, golden yellow, permanent white, gold, and silver.

COLOR NOTES

The bhupur's outer gate is gold; the inner gate is deep golden yellow. With the addition of white, the dynamic, bright red becomes more pink as you move toward the Yantra's center. The bronze color is achieved by mixing the outer red color with gold. Use the color image on page 96 to guide you.

Om Bum Budhaya Namaha

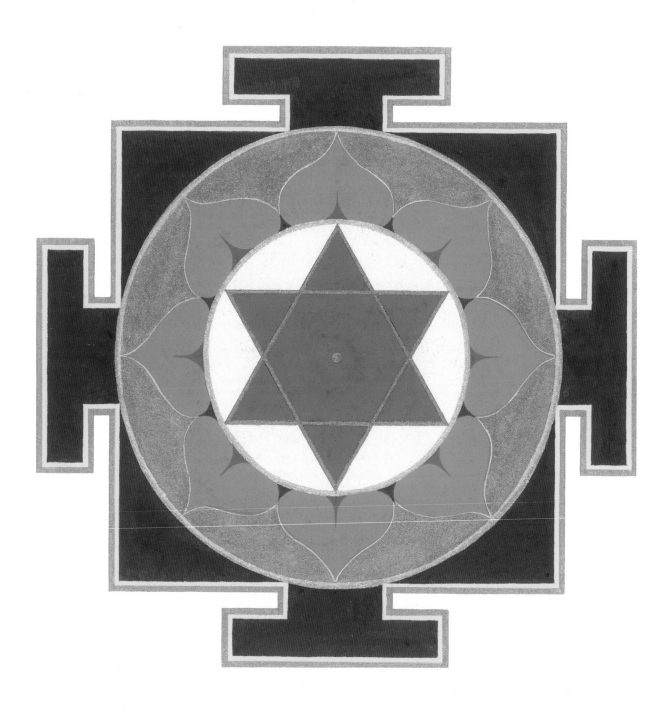

Intellect

The Intellect Design generates the capacity to use the heart-mind to discern, ponder deeply into the nature of reality, and uncover the solution to any problem you are facing. This design also aids in communication, giving the ability to listen and to express yourself in an effective way. Communication is essential to developing fulfilling relationships at work, home, and in your social life.

Contemplating this Yantra, tranquillity is found through the symmetry and simplicity of the image. The beautiful sea greens and metallic colors bestow a calming effect upon the viewer, bringing balance to the body and mind, and especially benefiting the nervous system. The healing properties of green come from its composition of yellow and blue. The greens of the Intellect Design are said to be as brilliant as a blade of fresh grass and as soothing as a pastoral scene. I find working with the greens in this design very soothing. After immersing myself in the drawing and painting, I feel refreshed as if I'd taken a walk out in nature. The color emits a significant amount of replenishing energy.

Once harmony is restored within, you will find yourself more flexible and adaptable to external situations. Rigidity of mind and stiffness in the body will both be significantly reduced. If you are feeling stuck, either physically or mentally, constructing this design will be helpful now. You'll be able to "go with the flow" as you feel more centered and confident about the bigger picture and your relationship to it. There is an ever-youthful, playful quality generated by this design, which promotes the flexibility and curiosity of a child. The Intellect Design relates to the planet Mercury and this Yantra sparks mercurial, quicksilver, fast-thinking, movable, and adaptable qualities. As the smallest planet in the cosmos, Mercury is seen as a young planet, echoing the ever-youthful quality imbued in the design.

The gemstone that inspires the colors within this design is the emerald. The colors of an emerald vary greatly from bright yellow-green to a deeper blue-green. The central six-pointed star in the Intellect Design captures the beauty of the most pure emerald, and the most clear and peaceful heart and mind.

The Intellect Design sharpens your ability to use the mind as a spiritual tool. Questions may arise that encourage you to go more deeply into spiritual subjects and see the wholeness of an object, person, or situation. These are not superficial questions, but ones that probe into the heart of the matter. If you are desiring to connect with

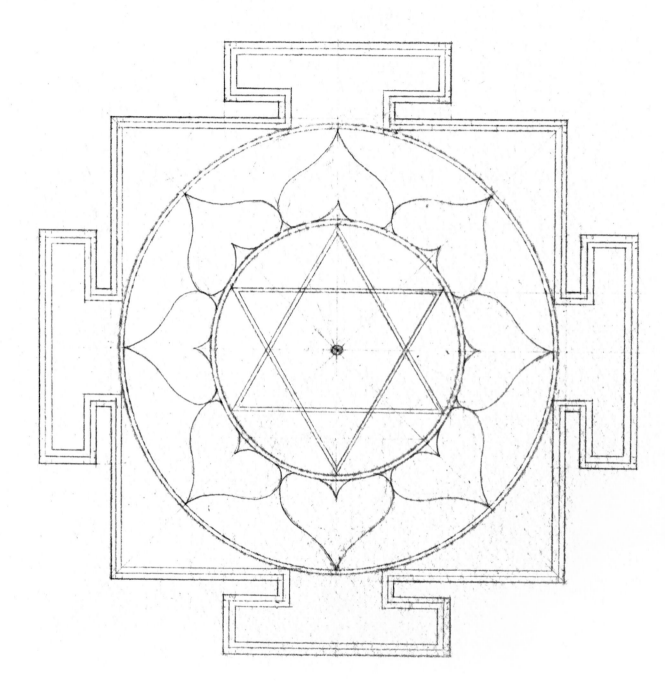

Hand-drawn Intellect Design

your inner peace through meditation, this is a good Yantra to focus on to begin. This design opens doorways to meditative practices that focus on observing the nature of the mind by coming to a place of stillness within.

The sound vibration for Intellect is:

Om Bum Budhaya Namaha

(OM BOOM BOOD-HI-YAH NAHM-AH-HA)

This means: I honor the purity of the Intellect within.

By repeating this sound (either externally or internally) while working with the visual Yantra, a deep quiet will penetrate the body and mind allowing clarity and harmony to be restored.

Intellect Recipe

MANTRA

Om Bum Budhaya Namaha

THE SHAPES

Bhupur (p. 32) Six-pointed star (p. 69)

Circle (p. 44) Bindu (p. 80)

Petals (p. 47)

ASSEMBLING THE SHAPES

1. Construct the bhupur and make the inner gates (p. 34)

2. Draw the outer circle (p. 46)

3. Create one circular band to contain the eight petals (p. 49)

4. Draw the eight petals (p. 51)

5. Follow the steps for drawing the six-pointed star (p. 71)

6. Finally, place the bindu at the center (p. 82)

7. Erase all guidelines and extra markings

DESIGN NOTES

A calming range of greens makes up the Intellect Design. The base mid-green color, with the addition of blue, creates a blue-green hue in the petals that lends a richness to the image. You will notice that the metallic colors here are switched from their usual positions within the Yantra: the background to the petals is gold, appearing reddish bronze next to the green. This lures the viewer's gaze to glide across the greens to the bindu. Gazing at this balanced design, with its subtle interplay of green and blue with the metallic colors, is soothing and centering, bringing one's awareness to rest at the heart-mind.

COLOR

Colored pencils: A range of greens and blue-greens, light yellow, white, gold (or light brown), and silver (or gray).

Gouache paints: Permanent green, cerulean blue, lemon yellow, permanent white, gold, and silver.

COLOR NOTES

The bhupur's outer gate is gold; the inner gate is lemon yellow. The blueish green color of the petals sits upon a golden background. The bhupur is darker green, the star is a vibrant yellow-green. Use the color image on page 102 to guide you.

Om Brim Brihaspataye Namaha

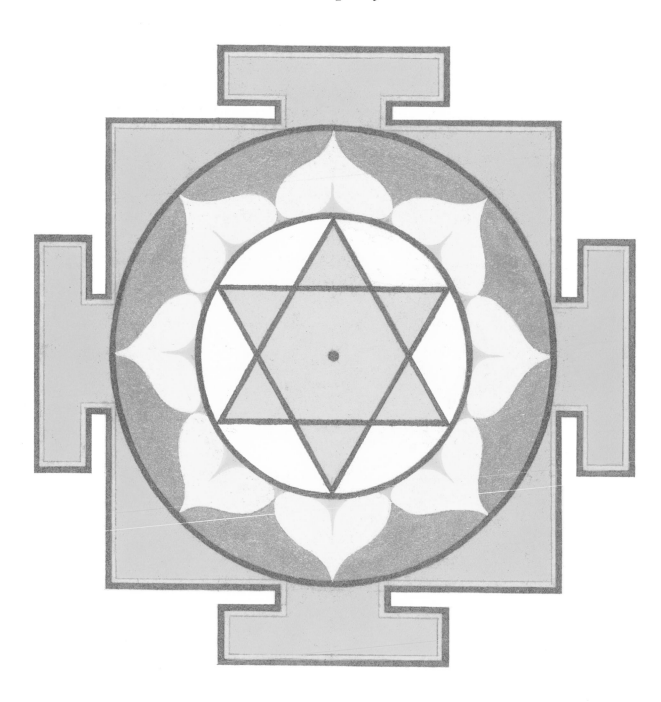

Expansion

The Expansion Design of golds and yellows rests upon the six-pointed star. This image creates expansion in your life so that you may share your unique gifts. You are bestowed with nature's riches; this Yantra helps you to recognize and use them actively in your life. To be of service to others is an expression of your wealth.

Community, gathering, and sharing of spiritual knowledge are highlighted by this design. Ritual is an important aspect of becoming familiar with the expansion energy. You can begin by making a daily personal ritual dedicated to what you would like to grow in your life—whether it is your business, your bank balance, or your devotional heart. The dedication, when affirmed daily, will begin to manifest in your life in concrete ways. Surrounding yourself with the light colors of this design—white, yellow, and gold—will also attract new levels of opulence to you.

The Expansion Design corresponds to the planet Jupiter. Jupiter is the largest and heaviest planet in the solar system. The vastness that emanates from this design expands the mind and broadens thinking. The planet relates to the word *teacher* and to the ability to teach, learn, and illuminate. This auspicious quality of expansion develops a strong intuition. Highly intuitive people feel guided to do the right thing at the right time, knowing when to act and when to refrain, flowing with life.

The yellow ray is balancing for digestion and the internal organs. The color is uplifting and useful in treating depression and lethargy. The Expansion Design is influenced by the yellow sapphire—a distant cousin of the more popular blue sapphire—found in yellow, golden, orange, and white hues. The most pure yellow sapphire is lemon yellow and is surprisingly heavy, creating another link to the weighty planet Jupiter. The six-pointed star at the center of this design is the rich lemon yellow color.

The energy of the Expansion Design is both relaxing and energizing. In the same way that muscles expand when relaxed, I feel that when I "expand" and feel the spaciousness this Yantra produces, I am able to decompress from mental, emotional, and physical stress. This extra room allows me to tap into a wealth of energy and inner resources.

Sharing is a natural outcome of feelings of immense well-being, enthusiasm, and zest for life. True wisdom comes when one is ready to share the fruits of lessons learned along the way. The abundance of goodness this design provides can be used as a general tonic for well-wishing, good luck, and success.

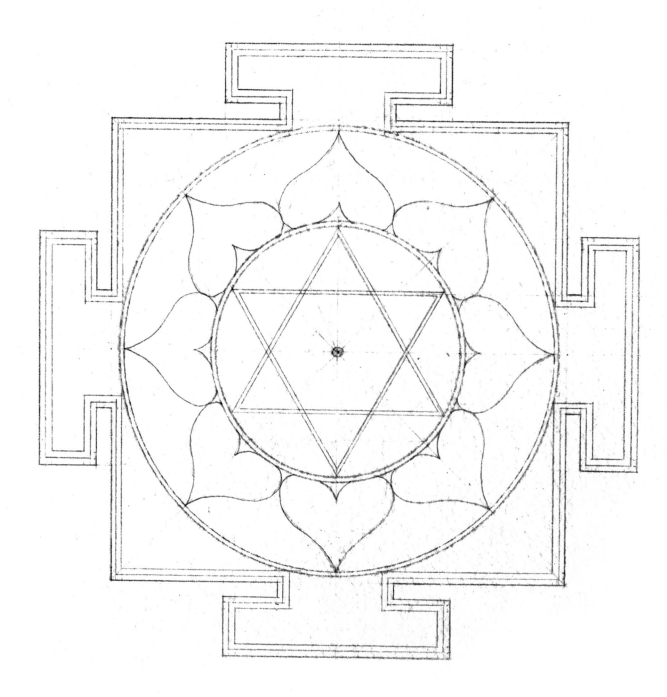

Hand-drawn Expansion Design

The sound vibration for Expansion is:

Om Brim Brihaspataye Namaha

(OM BRIM BREE-HAAS-PAT-AI-YAY NAHM-AH-HA)

This means: I honor the energy of abundance and generosity.

By repeating this sound (either externally or internally) while working with the visual Yantra, the quality of expansion will present itself to you.

Expansion Recipe

MANTRA

Om Brim Brihaspataye Namaha

THE SHAPES

Bhupur (p. 32) Six-pointed star (p. 69)

Circle (p. 44) Bindu (p. 80)

Petals (p. 47)

ASSEMBLING THE SHAPES

1. Construct the bhupur and make the inner gates (p. 34)

2. Draw the outer circle (p. 46)

3. Create one circular band to contain the eight petals (p. 49)

4. Draw the eight petals (p. 51)

5. Follow the steps for drawing the six-pointed star (p. 71)

6. Finally, place the bindu at the center (p. 82)

7. Erase all guidelines and extra markings

DESIGN NOTES

The magnificence of the Expansion Design comes from the rich golds and yellows placed next to the metallic colors and white. Each color gives a spacious open feeling. The reflected light from the metallic surfaces can add to the feeling of light coming from the design. As the mind expands to encompass the golden ray of light from the Yantra, the field of infinite possibilities arises from within. To be able to see the highest truth and envision the highest outcome in all situations is the blessing of this lemon and golden design.

COLOR

Colored pencils: A range of yellows, white, gold (or light brown), and silver (or gray).
Gouache paints: Golden yellow, lemon yellow, permanent white, gold, and silver.

COLOR NOTES

The outer gate of the bhupur is gold; the inner gate is lemon yellow. The bhupur itself is a deeper golden yellow and the petals are a paler shade of the same color. The eight petals rest on a silver background. The star is a bright lemon yellow. Use the color image on page 108 to guide you.

Om Shum Shukraya Namaha

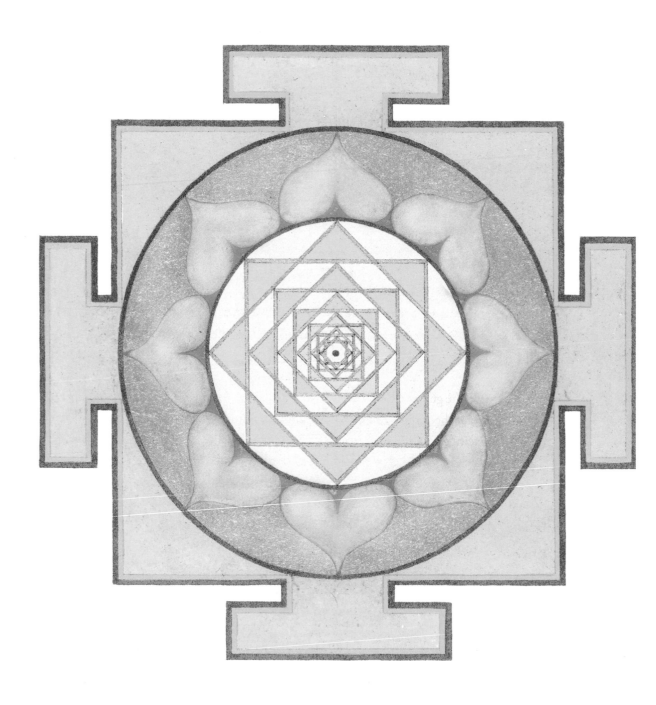

Bliss

Meditating upon the Bliss Design is like looking through a doorway to the creative, sensuous self. This design stimulates the feminine impulse of creativity and the play of the senses. The refined arts such as poetry, fine art, music, and literature are represented by this Yantra. Cultivating an appreciation of the arts and participation in their creation will be greatly enhanced by working with the Bliss Design.

Using the senses as a method for creating a bliss-filled meditative experience is one of the great spiritual paths and is encouraged by work with this design. By observing beauty through the eyes, ears, touch, taste, and scent the subtle realms can be experienced. The healing arts such as aromatherapy, color therapy, and healing with sound and touch help you to connect with your sensual self. An attraction to the finer elements of sensation—wearing smooth fabrics such as silk and cashmere, eating delicacies, and living within a beautiful environment—will all help to channel the senses and their perception inward to a place of silence. Surrounding yourself with comfort and beauty can bring about a harmony within.

Venus is the planet associated with the Bliss Yantra. Venus is known across the globe as the planet of love. Romance, love, and the sensuous side of relating are highlighted through this design. If you are seeking love in your life, the Bliss Design will enhance the energy of attraction.

The diamond is the gemstone that inspires the colors and shapes of the Bliss Yantra. The hard edges of the diamond and its crystalline structure are echoed visually in the pairs of interlacing squares at the center of the design. The offset second square of each pair appears as a diamond shape. The diamond is the most attractive and has the highest refractive index of all gems. This means that more light can travel through the diamond, and that light is projected back out far more strongly than in any other gemstone. It has a self-luminous appearance, just as the luster of pure beauty seems to shine attractively from within.

The colors in the Yantra represent the pure light coming from the gemstone. White contains all of the colors in creation just as pure light does. The equal amounts of each color present in the diamond cancel themselves out, leaving white or pure brightness. These are seen in the Yantra as pale blue, mauve, and pink. Pink is the color of Venusian beauty. Silver—the metal for the planet Venus—is the dominant metallic color here.

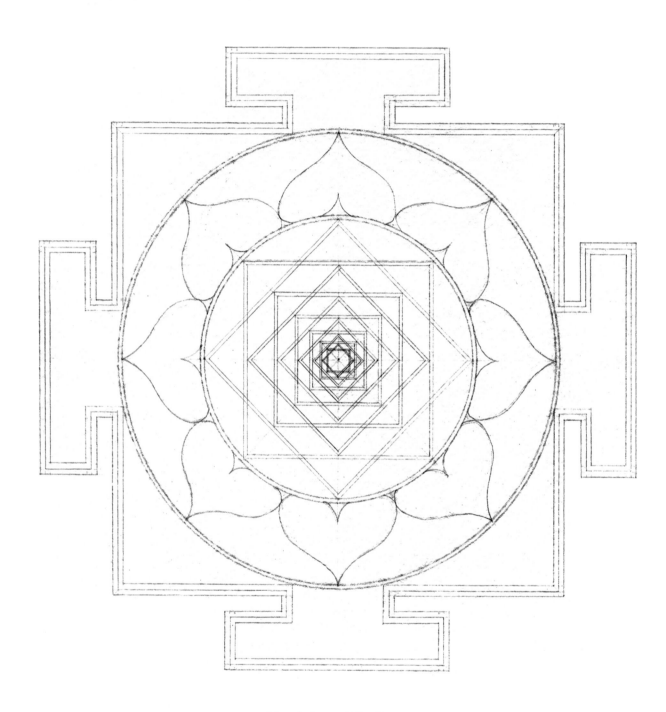

Hand-drawn Bliss Design

I find this to be a soothing design to contemplate. It takes patience to create the design, a slowing down. The feeling of infinity one gets when resting the gaze at the center of the Bliss Yantra speaks of a place beyond time and space. Deep rest and a peaceful place within are contacted.

If you tend to see the cup half empty, this Yantra is for you. The Bliss Design generates optimism and idealism, the ability to see the positive outcome and the best possible scenario in all situations. Seeing the inherent beauty within and around you generates a positive quality within the mind. Great wisdom and self-knowledge are awakened along with a desire to share these qualities with those eager to learn.

The sound vibration for Bliss is:

Om Shum Shukraya Namaha
(OM SHOOM SHOO-CRY-YAH NAHM-AH-HA)
This means: I honor the positivity and beauty that surround me.

By repeating this sound (either externally or internally) while working with the visual Yantra, the quality of bliss will present itself to you.

Bliss Recipe

MANTRA

Om Shum Shukraya Namaha

THE SHAPES

Bhupur (p. 32) Square (p. 74)

Circle (p. 44) Bindu (p. 80)

Petals (p. 47)

ASSEMBLING THE SHAPES

1. Construct the bhupur and make the inner gates (p. 34)

2. Draw the outer circle (p. 46)

3. Create one circular band to contain the eight petals (p. 49)

4. Draw the eight petals (p. 51)

5. Follow the steps for drawing the interlacing squares (p. 76)

6. Finally, place the bindu at the center (p. 82)

7. Erase all guidelines and extra markings

DESIGN NOTES

The beauty of the Bliss Yantra emanates from the subtle play of pastel colors against the silver in this unique design. The attractiveness of the Yantra is enhanced by the large pink petals and the mesmerizing pattern of six interlacing squares. When creating the interlacing squares, give the illusion of depth and space using the following two techniques: make the space between the double lines of the squares thinner as they approach the center, and make the blue color filling the triangles paler (with the addition of white) toward the center. Everything dissolves back into white until the eye reaches the gold of the bindu.

COLOR

Colored pencils: A range of pale blues, mauves, and pink, white, light yellow, gold (or light brown), and silver (or gray).
Gouache paints: Cerulean blue, magenta, lemon yellow, permanent white, gold, and silver.

COLOR NOTES

The outer gate of the bhupur is gold; the inner gate is lemon yellow. There is a play between the light blue in the bhupur and the triangles and the pink-mauve petals. The clean use of white and silver helps to lighten the whole Yantra. The eight petals rest on a silver background. Use the color image on page 114 to guide you.

Om Sham Shanaye Namaha

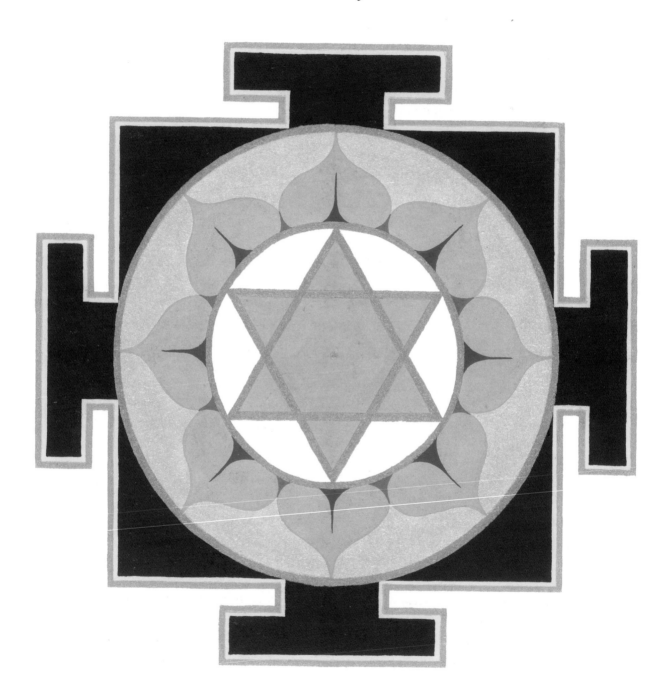

Organization

If you are drawn to the Organization Design, it is time for you to bring some order to the world around you to help you connect with the silence within. Disharmony arises if the work or home space is chaotic or cluttered. By clearing out that which no longer serves you and organizing that which remains, a huge sense of relief and wellness is brought to the body and mind.

Purification not only of the space around you, but also of the physical body could be a good idea for you now. Paying special attention to your diet, keeping it simple and nutritious, and developing an exercise regime that works for you will be most helpful. It has long been known that you can use the physical body as a focal point to develop spiritual awareness. A deep place of silence can be found by meditating on the physical body during all forms of physical exercise, including yoga asanas and tai chi, as well as when receiving bodywork and massage.

The planet associated with this Yantra is Saturn. Saturn is the slowest-moving planet in the solar system and is the farthest away from Earth. Saturn helps with attention to the details in your life and helps you methodically work through that which may seem to be taking a long time to come to fruition. Every project has its own time-line, and some take longer than others. For the longer projects this is your Yantra. It invokes patience, endurance, and the stamina not only to continue where others may have given up but also to thrive on the riches that can develop only when much time has been invested in something. With such persistence and faith you will experience a ripening and maturing as you arrive at your grace-filled destination.

The blue sapphire inspires the colors for this Yantra. This stone emits a starlike blue ray from its center and the star is found at the center of the Organization Design. A high-quality blue sapphire is the color of the neck of a peacock, or a velvety cornflower blue. The blue sapphire is the most powerful gemstone. The colors in this design are very dark, signifying this intense power in addition to the cold, dark quality of Saturn.

Saturn is known as the enemy of light. The quiet that comes from a dark, cavelike space is captured in the Organization Design and indicated as a helpful place to find stillness within. This design suggests a need for solitude or some quiet time away from noisy crowds. Taking a solitary walk or enjoying time alone in silence will be a good way to restore your connection to the sacred.

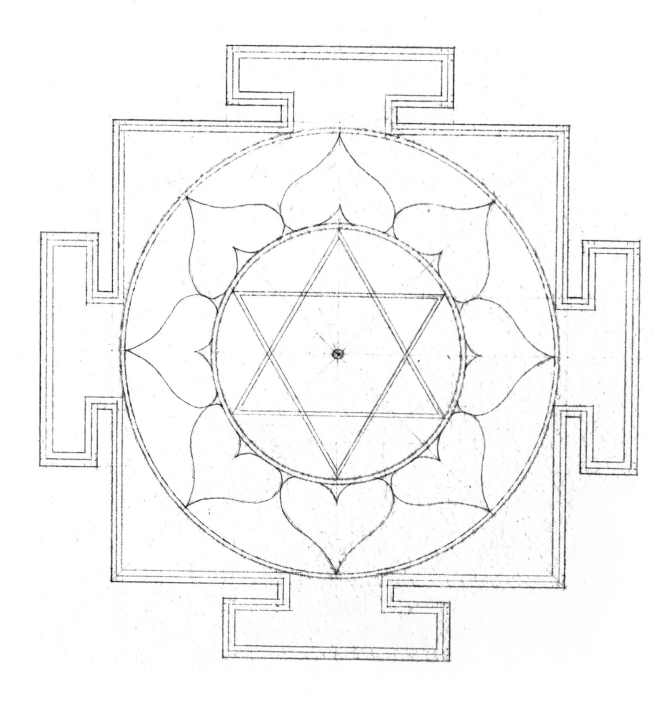

Hand-drawn Organization Design

Whenever I create the Organization Design I feel drawn inward in response to the dark blue colors. The centering effect the Yantra possesses is highlighted by this inward pull. By spending time in a quiet state, many emotions may surface that in the busyness of your day you generally do not notice. Here the witnessing and naming of the emotions that arise will allow you to let go of them and move into a deep place of inner peace.

The qualities of integrity, honesty, faithfulness, loyalty, and trust all stem from the lessons learned on some of the slower journeys we take through life. The wisdom garnered becomes a source of great dignity and light, which can inspire silence in those with whom you come in contact.

The sound vibration for Organization is:

<div align="center">

Om Sham Shanaye Namaha

(OM SHAHM SHAHN-AI-YAY NAHM-AH-HA)

</div>

This means: I honor the silence and order within and around me.

By repeating this sound (either externally or internally) while working with the visual Yantra, the qualities of organization and silence will permeate all you do.

Organization Recipe

MANTRA

Om Sham Shanaye Namaha

THE SHAPES

Bhupur (p. 32) Six-pointed star (p. 69)

Circle (p. 44) Bindu (p. 80)

Petals (p. 47)

ASSEMBLING THE SHAPES

1. Construct the bhupur and make the inner gates (p. 34)

2. Draw the outer circle (p. 46)

3. Create one circular band to contain the eight petals (p. 49)

4. Draw the eight petals (p. 51)

5. Follow the steps for drawing the six-pointed star (p. 71)

6. Finally, place the bindu at the center (p. 82)

7. Erase all guidelines and extra markings

DESIGN NOTES

In the Organization Design, the blues are seen upon a contrasting silver and white surface. This deep mix of blues—seemingly blue-black but created with the addition of both reds and yellows—gives a mysterious velvety shimmer that will lure you into the surface of the Yantra. The depth created by these colors is stunning. Gazing at the deep blue hues creates a feeling of light within. There is an awakening of the higher spiritual centers in the body through meditation on this color.

COLOR

Colored pencils: A range of dark blues, red, purple, deep yellow, white, gold (or light brown), and silver (or gray).

Gouache paints: Prussian blue, ultramarine blue, spectrum red, magenta, golden yellow, permanent white, gold, and silver.

COLOR NOTES

The outer gate of the bhupur is gold; the inner gate is deep golden yellow. The dark blue background is darker than the brighter blue star and the petals appear smoky with the addition of black and white. The space behind the eight petals is silver. Use the color image on page 120 to guide you.

Om Ram Rahuve Namaha

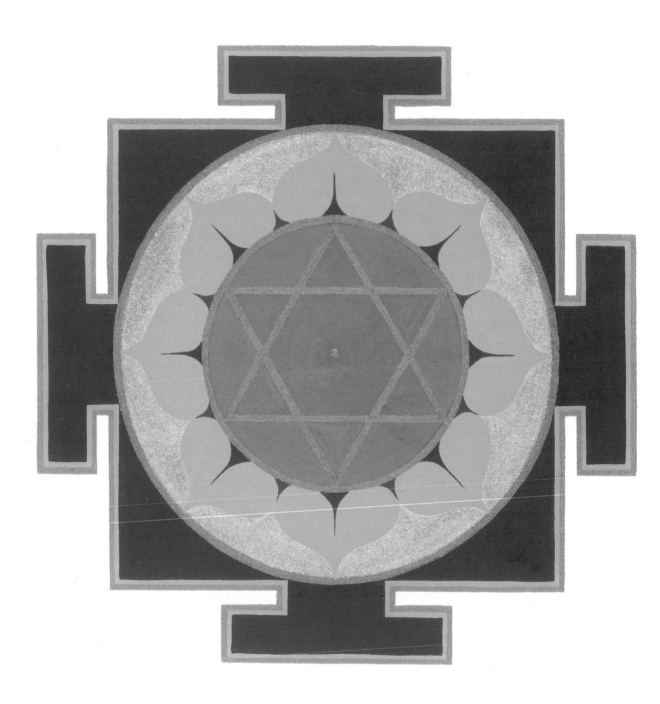

Uniqueness

The Uniqueness Design speaks to finding and following your deepest desires no matter how unusual or unacceptable they may seem to the status quo at this time. Each of us has a highly individualized part of our personality, a place where we go against the flow, where we feel like we are swimming upstream or reveling in our own magnificence. If you are attracted to the Uniqueness Yantra it is time to recognize that part of yourself now. This design brings an earthy, smoky color, encouraging new, groundbreaking, bright ideas to emerge from within.

By working with this Yantra a great energy force will be made available to help you hear and act upon your unique voice. By putting outmoded ways of thinking and being behind you, a new light is able to emerge. This can manifest in many different ways—from creating a unique work of art to starting a revolution! You have the capacity to instigate a meaningful and refreshing change in your life and within society.

The Uniqueness Design is associated with Rahu, the north node of the Moon and one of a pair of shadow planets known as the nodes. Ketu, associated with the Spirituality Design, is the south node. These shadow planets are eclipse points in the sky. Their influence upon human behavior as a celestial force is experienced in the same way as the planets', earning their position in the cosmos as shadow or half-planets. Due to the unusual nature of their form, they invoke that which is distinctive and mysterious.

The gemstone for the Uniqueness Design is the hessonite garnet; also known as gomed, the cinnamon stone, and zircon. The perfect gomed is said to be honey colored, while the archetypal color of Rahu is a smoky blue. These colors combine to create a design that is smoky brown with hints of blue, yellow, violet, and green. This rich combination of colors has a balancing effect on the emotions. Emotions such as doubt and fear can be soothed when overcoming external challenges.

If you are feeling a strong ambition to accomplish something in the world around you, this design will give the strength and conviction to move beyond obstacles or doubts that may come along the way. Whenever something is new there can be resistance to change or to receiving the ideas. Traveling to new places for inspiration and a new audience can be beneficial at these times.

Loving what is unique about my life is always brought to the forefront of my mind when creating the Uniqueness Design. We are all blessed with our own special path

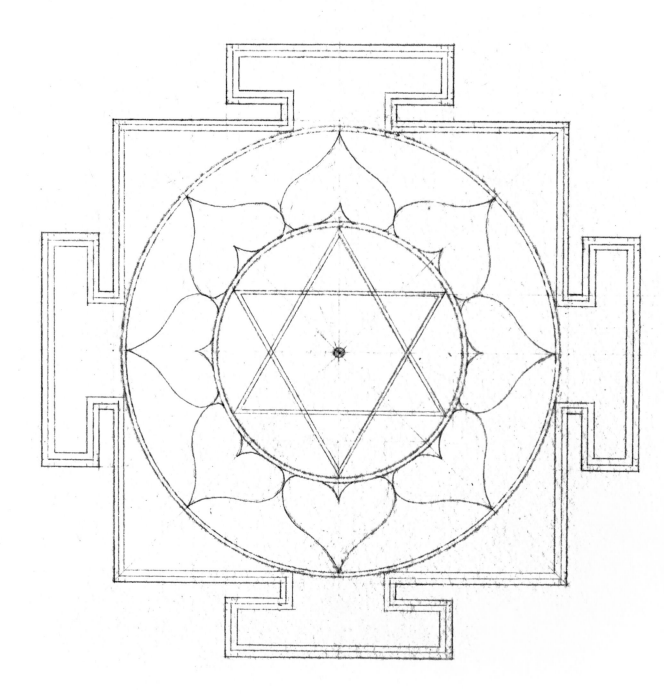

Hand-drawn Uniqueness Design

but at times due to conditioning and cultural beliefs our ability to see this becomes obscured. The Uniqueness Design helps to deepen your connection to your truth. The unusual color combinations and the feeling that the Yantra generates give a sense of courage, self-reliance, and fearlessness to experience life to its fullest. As you work with this design, finding and using your own unique voice will be freeing and joyful.

The sound vibration for Uniqueness is:
Om Ram Rahuve Namaha
(OM RAHM RAH-HU-VAY NAHM-AH-HA)
This means: I honor the uniqueness of my special journey in life.

By repeating this sound (either externally or internally) while working with the visual Yantra, the ability to manifest worldly desires and ambitions will gain clarity and momentum.

Uniqueness Recipe

MANTRA

Om Ram Rahuve Namaha

THE SHAPES

Bhupur (p. 32) Six-pointed star (p. 69)

Circle (p. 44) Bindu (p. 80)

Petals (p. 47)

ASSEMBLING THE SHAPES

1. Construct the bhupur and make the inner gates (p. 34)

2. Draw the outer circle (p. 46)

3. Create one circular band to contain the eight petals (p. 49)

4. Draw the eight petals (p. 51)

5. Follow the steps for drawing the six-pointed star (p. 71)

6. Finally, place the bindu at the center (p. 82)

7. Erase all guidelines and extra markings

DESIGN NOTES

In the Uniqueness Design the earthy, smoky color is a complex mixture of blues, browns, and reds. The special chemistry of colors has a profound effect upon your own internal chemistry. The depth of colors takes you to a deep place of knowledge within. The contrasting brightness of the pink and mauve center indicates that light is coming out of the darkness. A new you is emerging where self-love and self-expression can find their voice.

COLOR

Colored pencils: A range of warm purples and browns, white, pink, mauve, deep yellow, gold (or light brown), and silver (or gray).

Gouache paints: Raw umber, burnt sienna, yellow ochre, scarlet lake, magenta, ultramarine blue, golden yellow, permanent white, gold, and silver.

COLOR NOTES

The outer gate of the bhupur is gold; the inner gate is deep golden yellow. The murky brown colors of this Yantra are interesting to create. Experiment with the suggested colors to create browns, mauves, and pinks. The petals are a lighter color of the same brown as the bhupur, and the star is this color with additional magenta. The background to the star contains the color of the star with additional ultramarine. Use the color image on page 126 to guide you.

Om Kem Ketuve Namaha

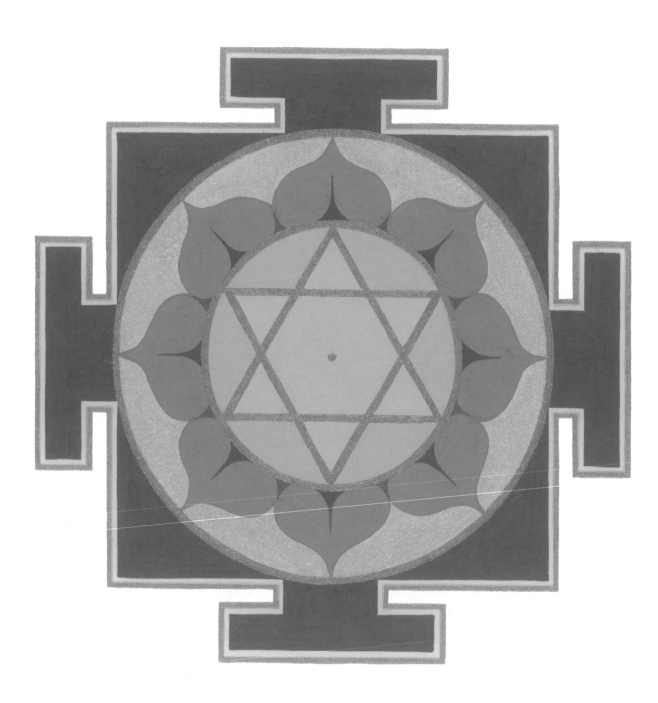

Spirituality

As the name suggests, the Spirituality Design leads us away from material concerns in pursuit of the Divine. The murky colors of blue, sage, and ochre greens inspire a mystical inward journey where attachment to worldly affairs fades in favor of inner wisdom and knowledge.

If you are feeling highly sensitive or emotional and desiring a retreat to think, philosophize, or probe into life's deeper questions, this design will help. Interest in the healing arts, esoteric healing, and developing your intuition will be heightened through this Yantra. There is a fundamental shift that takes place with the realization that the self is part of the universal life force. By withdrawing from that which emphasizes our differences in society and focusing on the unity of consciousness that pervades the entire cosmos, you will find yourself in a place of balance with the self and the laws of the universe.

The Spirituality Design connects us with the south node of the Moon, Ketu. Ketu is Rahu's counterpart in the pair of eclipse points known as nodes or the shadow planets. Ketu is the more introverted aspect of the nodes and can show you the way to find your own spiritual path or religion. The nodes always highlight the unusual and the secretive. Don't be surprised if you find yourself drawn to some mystical self-study at this time.

Cat's Eye, also known as Chrysoberyl, is the gemstone related to the Spirituality Design. Its key characteristic is a line of light that emanates from the greenish brown stone. The line looks like a cat's eye at night. The light is a symbol for the awakening of our own spirituality amid the darkness, illusion, and separation that precede it. By learning the lessons of our "shadow" self, the spiritual light or wisdom is revealed. This may be a time for you to surrender to the challenges of external situations and see them as life lessons gracefully guiding you to find answers within.

Creating the Spirituality Design, I feel drawn into a place of supreme quiet and ecstasy. It connects me with an inner place of resting and being that is so all-absorbing that the desire to go out and do social, worldly activities loses appeal. This is the natural outcome of having a rich inner spiritual life. There is no need to give up anything in order to be "spiritual"—by itself that which no longer serves you will fall away when

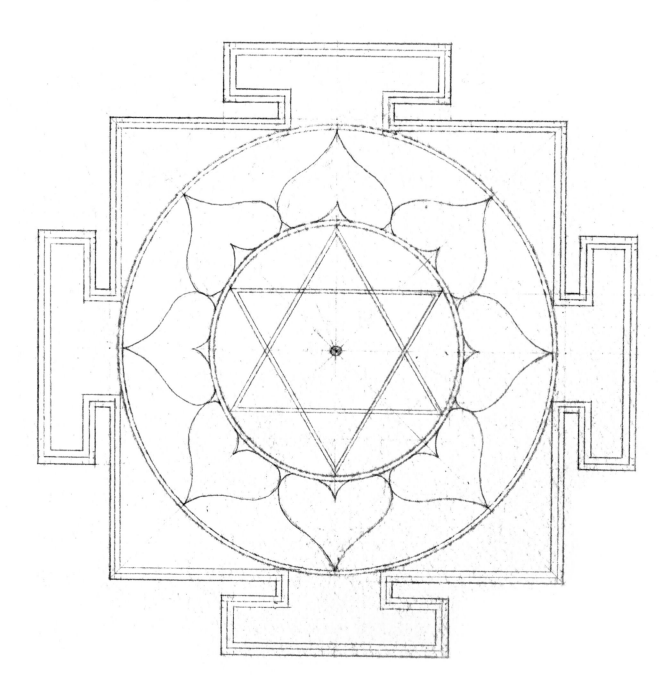

Hand-drawn Spirituality Design

the focus changes for you. You will discover how the Yantra serves you: whether it is useful as a way to connect to your spirituality, mark an important passage in your life, or transition into a new way of being and perceiving the universe and your relationship to it.

The harmony that arises from the empathetic view of the universe that this design generates gives wisdom and insight into the workings of nature. Through the Spirituality Design, Ketu fulfills its role as a doorway to the liberation of the soul through eternal bliss and tranquillity.

The sound vibration for Spirituality is:

Om Kem Ketuve Namaha
(OM KAME KAY-TOO-VAY NAHM-AH-HA)

This means: I honor the tranquillity and supreme bliss of my true nature.

By repeating this sound (either externally or internally) while working with the visual Yantra, an inner realization of the nature of your spirituality will occur.

Spirituality Recipe

MANTRA

Om Kem Ketuve Namaha

THE SHAPES

Bhupur (p. 32) Six-pointed star (p. 69)

Circle (p. 44) Bindu (p. 80)

Petals (p. 47)

ASSEMBLING THE SHAPES

1. Construct the bhupur and make the inner gates (p. 34)

2. Draw the outer circle (p. 46)

3. Create one circular band to contain the eight petals. (p. 49)

4. Draw the eight petals. (p. 51)

5. Follow the steps for drawing the six-pointed star. (p. 71)

6. Finally, place the bindu at the center. (p. 82)

7. Erase all guidelines and extra markings

DESIGN NOTES

In the Spirituality Design, the harmonious image of the six-pointed star within the circle of eight petals draws you in to a hypnotic place. The deep sage green color of the bhupur acts as a gateway from the external to the internal part of yourself. Once you have moved through this space you are receptive to higher understanding. The play of the lighter shades of green and yellow ochre with the shimmering gold and silver lines brings your focus to the center of the Yantra as you find a new place of rest within. It is quite extraordinary how dramatic is the effect of working with and gazing into each Yantra. This is no exception. The special pull of the Spirituality Design will help you connect with inner resources and recognize a new vocabulary for your own spiritual journey.

COLOR

Colored pencils: A range of greens, browns, white, deep yellow, gold (or light brown), and silver (or gray).

Gouache paints: Viridian lake, permanent green, cerulean blue, yellow ochre, lemon yellow, golden yellow, permanent white, gold, and silver.

COLOR NOTES

The outer gate of the bhupur is gold; the inner gate is deep golden yellow. This smoky sage green design contains viridian lake (blue-green), with some yellow ochre to produce the khaki-type color of the bhupur. The petals are lighter with the addition of lemon yellow and white. The star is a lighter version of the bhupur color, and the background to the star is a lighter version of the petals. Use the color image on page 132 to guide you.

5 Sealing the Practice

Conclude your time preparing the chosen design, at whatever stage of completion you have reached, with a period of stillness. This intentional pause will give the healing powers of the activity a chance to be absorbed at the deepest level. Here the process is completely receptive. You are focusing on the inward experience of having performed an external activity. This can be done midway through the construction and again after the coloring is complete.

The Yantra in Progress

If you are midway through the creation of your Yantra when you choose to stop for the day, put your tools down but keep the design in front of you. Observe the stages that you have traveled through to arrive at this point. You can ghost the lines and shapes in your mind, mentally redrawing or coloring them. After a few minutes, close your eyes and allow the colored shapes to present themselves. With closed eyes you will see the after-image of the design in your mind's eye. By bringing your awareness into your body, a wave of calm will move through you. After a period of active meditation such as Yantra painting, it is blissfully easy to slip into a deeply relaxed state.

The Completed Design

Once you have completed the drawing and coloring of your design, the gold bindu at the center will be your focal point. Set your Yantra before you while sitting comfortably, either at your desk or on a cushion on the floor. Place the Yantra at a height where it is comfortable for you to gaze at the bindu effortlessly.

As you gaze at the bindu over several minutes, you will see the colors and forms of the whole Yantra in your peripheral vision. Recall the process it took to arrive at this point, step-by-step in your mind. Journeying back in time through the Yantra's construction carves a strong impression in the mind. The colors and lines will begin to seep into your being at a deep level and their specific benefits will be further enhanced. In this way you will seal the benefits of the Yantra's creation.

Invoking the mantra is useful at this stage. For example, reciting Om Kum Kujaya Namaha while gazing at the Passion Design will harness the full potential of the passion's arousal from within. It is like calling someone's name—and having the person respond. In the same way, when the mantra is invoked the design "hears" its name and is enlivened as a result. The mantra can be repeated aloud or silently in your mind. Experiment with the mantra and see which method of recitation is most pleasing to you. To intensify the use of your mantra you can choose to count the number of mantra repetitions you make while gazing at the center of your Yantra. A powerful number is 108, the exact number of beads found on a thread of *mala* (the Hindu equivalent of rosary beads).

After a period of gazing with open eyes at the bindu, close your eyes. Allow the after-image to wash over your internal awareness. As the image fades observe the sensations and tranquillity that arise. Sit comfortably in this inner space for a few more moments. When you feel the process is complete and a peaceful place has been reached, a feeling of energy wells up inside and the desire to move occurs. In my experience this can be after five minutes or twenty-five minutes; the time is inconsequential. However, this should be an effortless pause. If strain or mental resistance appears while sitting, this is a sign that the body is ready to move. Slowly deepen your breath and energize your body before transitioning into the next part of your day.

Each time you sit with your completed design the fruits of the practice will be more strongly experienced. You are making deeper grooves in your internal atmosphere. This does take time; here time implies repetition of practice. Traditionally, to fully reap the benefits of a specific design, one spends a few minutes meditating upon the bindu each day for forty days upon completion of the Yantra. It can be helpful to start the forty days on the day associated with the particular Yantra. For example, start

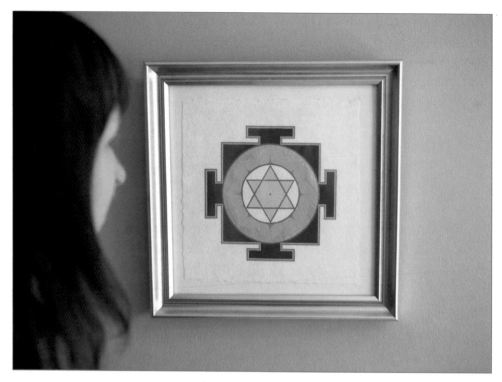

Meditation with a Yantra

the Nourishment practice on a Monday. (See page 158 for more on the relationship between the days of the week and your chosen Yantra.)

Time is needed for all changes in nature to complete their process. Fall slowly becomes winter, babies take nine months to arrive from conception to birth, and harvesting crops occurs well after the seeds have been sown. Harnessing the positive effects of creating a Yantra is no different. New habits or patterns of behavior associated with your chosen design will produce lasting transformations if they have been worked on for some time. This work occurs in the creation of the Yantra, with the use of the mantra, and in subsequent periods of stillness. It takes time for new habits to form. Physical behaviors are the result of shifts in thinking; seeds are sown on the mental level and become instrumental in creating substantial changes in the physical realms.

There are occasions when the power of the Yantra is noticed only in retrospect, in ways so subtle that you may not at first make the connection. You may notice in the weeks after having created the Expansion Design some evidence of a concrete project or enterprise expanding for you, or there may be a general quality of expansion that

is detectable. These are the forces behind the lines and colors of the Yantra beginning to produce results. Once you have established a connection with it, the Yantra keeps working for you.

Finding an appropriate place to keep your Yantra, where you will be able to interact with it daily, will be discussed in chapter 8.

2 Background to the Practice

Using Yantras to Evoke Everyday Mindfulness

6 Meditation in Action

Creating Yantras is a form of meditation that uses activities, in this case drawing and coloring, as a method for gaining inner peace. There are many forms of meditation, and each one uniquely addresses a path you can take toward feeling more centered, peaceful, and joyful.

The experience of meditation can be cultivated while sitting still and watching one's breath, repeating a mantra, or observing the sensations of one's body in stillness. Meditation can also be experienced during more dynamic activities such as walking or gazing at a Yantra or candle flame. These varied forms of meditation are training practices, used to develop the art of concentration in order to bring the mind, body, and senses into awareness in the present moment. When this happens, the true state of meditation begins: a deeper awareness arises effortlessly (after all, true meditation is a pure state of being), and the realization occurs that there is an innate witnessing presence within each one of us. This witnessing presence is often known as the universal mind or, simply, the self. It denotes the deepest part of ourselves that unites each of us with one another. It is the self that watches the comings and goings of the smaller mind—the personality and all its idiosyncrasies. The beauty of finding this deeper connection within you is that it yields a spaciousness between that which you do and

that which you are. In this spaciousness, peace will arise; tranquillity is all pervading and a limitless supply of energy is yours for the taking. This self is our connection to the Divine.

How do we connect with this deeper self? With this universal mind? To spirituality in our lives? And what has shaped the path we will follow?

The nature of the small individual mind (as opposed to the universal mind) is to chatter, judge, analyze, and be restless. This restless mind is known as the expression of the individual self, that which shapes our personality and our unique gifts in the world. There are many time-tested methods for stepping back from this agitated mind to become a witness to its activities. In this one gesture of stepping back, everything changes. It is like being in the middle of a torrential river, and then finding oneself on the bank instead, observing the flow of water. From the position on the bank all is beautiful and effervescent; amid the torrents themselves, however, there is life-threatening panic. And so it is with the mind. The body and emotions are directly related to the activities of the mind. And it is easier to reengage with the mind from the shore when seeking to effectively impact the health of the body and emotions.

There is a beautiful sutra from the Mundaka Upanishad, an ancient text from the Hindu tradition, which illustrates these two faculties we each possess: "Two birds sit on the same branch of the same tree. One eats, and the other looks on."

This simple image has a profound underlying message, opening up and laying bare an entire way of life, completely in harmony with the rhythms of nature. The two birds perched on the tree are the individual mind and the inner (or universal) self, respectively. These two dwell in the same body. While the individual eats both the sweet and sour fruits of our existence, the inner self, which realizes its true nature, watches in complete detachment.

Much of the activity of the mind involves projecting our thoughts into the future: What will I do next? How will I accomplish that? When will this happen? And ultimately, When will I die?

And the opposite line of thinking: Where did I come from? Why did I do that? Why did that just happen? And again, at the farthest point back, Why was I born?

The mind swings like a pendulum between these two lines of thinking—from the past to the future. Through thousands of years of spiritual practices we have learned that it is only in the direct experience of the present moment that the spiritual truths can be revealed and the deeper meaning of our existence understood. These insights are available to us through meditation, where we connect with each other at a deep level by accessing the universal intelligence that allows us to feel we are in tune with the forces of the universe.

Present-moment awareness, this feeling of being on the bank of the river, allows you to perceive clearly the nature of situations and to see people as they are without false projections and reactions. It also gives the valuable gift of being able to see the connected nature of events and time and place. Seeing this, and connecting with the laws of the universe as they unfold before you day to day, it is natural to make the right decisions at the right time. This is in fact wisdom, and, when approached with an open heart, it is compassion. It has been said that a fool is one who does the right thing at the wrong time. Indeed, this is frustrating and creates a whole chain of reactive situations that take us away from the inner peace that we are so keen to connect with.

The interesting thing about being on the bank of the river is that instead of feeling removed from the vitality of the river, you are more able to appreciate it fully—the sounds, the movement, the play and force of the water. Just stepping to one side and perceiving the situation devoid of story and desperation brings deep insights into the movement of nature (in this case the river) before you. From there, it is not a far leap to learning to appreciate the nature of the deeper mystical truths that bring bliss into the realms of experience. Bliss arises from this ability to be present in each moment. It is the natural state when the distractions of the mind and body have been sidestepped.

Active meditation may sound like a paradox to those who have experienced this connection to the self only while in a still state. Spirituality in all its myriad forms requires transcendence, and transcendence generally implies silent awareness. How is it possible to reach this place of inner peace in the midst of activity? It appears to be a contradiction in terms. The infinite dynamism of creation coexists with the infinite silence of its source. How then do we incorporate silence into our activity?

To have success in your meditation practice it is essential to find the method that is most suited to your personality and tendencies. For some, it is not the act of sitting that works but a strong focus on breathing and physical postures. For others, devotional singing and dancing might help transcend the smaller mind and connect with the universal. The important thing here is to see that there are many ways to meditate, and that by experimenting with some of these approaches you will soon get a sense of what works for you. You will need the discipline to start a meditation practice, but in a short period of time you will receive positive feedback if the selected path is an appropriate one for you to follow; you will feel reassured by the peaceful feelings generated from inside and by an ease in response to those with whom you come in contact.

The rishis say, "Have your attention on what is and see its fullness in every moment. The presence of God is everywhere. You have only to consciously embrace it with your attention."

There are many ways of doing this. If you have found "just sitting" to be a frustrating practice, active meditation may be for you. This book offers a spiritual practice that cultivates mindfulness and a peaceful awareness of oneself in the midst of activity. The practice of creating a Yantra is one of many traditional forms of active meditation. It involves the mind and body in a devotional and one-pointed practice that includes drawing, painting, reciting mantras, and absorbing all of this in the period of stillness that follows.

By giving the mind a beautiful activity to focus on, the deeper part of ourself is given the space to emerge. Soon there is a shift that takes place from the "thinking and doing" mind to the more restful and replenishing "witnessing" mind. This shift can happen in any form of activity, but an ancient practice such as creating Yantras is particularly suited for naturally bringing to the surface the qualities of silence, joy, and tranquillity. Thereby the paradox is resolved—you will arrive at a place of deep bliss and transcendence amid activity.

Creating Yantras is an ancient practice and there is great comfort in engaging in a sacred ritual that has been practiced by others for thousands of years. For me, there is a joy in the collective ritual, enriched through the ancient wisdom and timeless beauty of the activity and the images created. It was a relief for me to discover that I could arrive at such peaceful states through this kind of practice and have a direct experience of the universal mind amid activity.

You could do the practices in this book with a dry sense of mechanical concentration, or you can do them as a celebration of your sacred self. The latter I believe generates a richer experience. The richness of the intention you have at the beginning will allow you to tap in to deeper aspects of the practice. By naming the sacred intent of the activity you are about to engage in—to uplift the quality of the experience you will have—a ritual is created. Your actions become an offering to the Divine and a means of liberation.

Focus on the Process

The common thread in the active forms of meditation is the emphasis on the process—on becoming engaged in the process itself without trying to predetermine the outcome. This brings you into the present moment (rather than projecting into the future or relating to previous experiences and reliving the past) and puts you into a creative space where the unimaginable becomes possible. You begin to see that the process develops a momentum of its own and that Nature, the creative impulse, decides how

the process will turn out. Ultimately, success and failure depend more on the support of Nature than on your own actions. This is an important concept to stay with throughout the practice.

It is easy to take praise or blame for the results of one's actions. It is easy to say "I did this, I did that," or "look how beautifully I did this or that." This form of aggrandizing the "I" does you a disservice. It brings in the personal; you are taking the activity and its results personally which makes you self-conscious. In this self-conscious state where you are deciding how things will turn out, you are limiting yourself from the full range of possibilities available to you at that moment. You are, in a way, predetermining an outcome and attaching yourself to some predefined goal.

It is only through relinquishing your attachment to the outcome of an event that you can truly enjoy the process and develop nonattachment to the fruits of the practice. Ironically, the detachment allows you to be more absorbed in the process, making you more aware and alert to the nuances and surprises along the way.

This point is exemplified by the archer aiming at his target: the archer can only pull back his bow, point his arrow, and release. He cannot control any sudden gusts of wind, which may blow his arrow off target.

By cultivating a heightened awareness of the present moment and your interaction with the greater play of Nature, you will see the deeper connections and rhythms present in the laws of the universe.

Traditional Forms of Active Meditation

In addition to creating Yantras, there are several other traditional forms of active meditation: walking meditation, creating sand mandalas, and cultivating meditative awareness in daily activities such as cooking and gardening.

Many of these forms were developed in monasteries as a way for the monks to appreciate the activities of the day as forms of meditation. They would have some form of exercise, a walk, and do their necessary tasks—the cooking and the dishes—maintaining the devotional one-pointed awareness in which they had been absorbed during their long hours of sitting in silence.

Walking meditation is a beautiful practice where full awareness is given to the steps you take, the breath that moves through your body, and the sensations and images that flood the experience. During a walking meditation there is a half smile on the lips of the meditator. This points to the joy and happiness within, and becomes an expression of that inner light. A practice like this dramatically alters your habitual

moods and reactions to situations, teaching you to respond from a place of joy and tranquillity.

Tibetan Buddhists create sand mandalas as a ritual celebrating the Divine. The mandala, a more complex form of a Yantra, is created with colored sand in a beautiful circular image by monks while they recite special prayers. The whole process is performed as an offering to purify and uplift the energy for a much-needed cause. At the end, the "result"—the beautiful image—is swept up and the contents are offered to a nearby river to take the prayers back to the earth. The process itself teaches nonattachment to the outcome, as there is nothing left to be attached to. When the mandala is complete, it is all blown away or mixed into the sand at the bottom of the river.

It has recently become popular to knit as a spiritual practice. I believe this is another way to integrate activity and mindfulness. Knitting clubs and workshops are spreading throughout the yoga community, providing a way for yogis to move from the mat or the cushion back into community life, while keeping intact the thread of connection to the self.

Real joy comes from realizing that this moment is everything. Bringing the element of ritual and one-pointed awareness to seemingly mundane activities reminds me of a story of a Benedictine monk who shared his experience of washing the dishes. He spoke of how he felt God was talking. He found if he handled the dishes gently they made a beautiful jingling sound, but if they were thrown here and there they cried. For him, dishwashing became a form of worship.

The teaching here is simple but profound: while working, focus on working; while cooking, give the process your complete attention; while brushing the teeth, make that your meditation; while talking, focus on talking. Whatever the activity, focus on it fully, and let that be your meditation.

Meditation and Life

Making a smooth transition from your inner meditative practices to your external activities is often a challenge. It can be terribly jarring to come from the deep silence experienced with closed eyes seated upon a cushion and move back into the world of visual and audible stimuli, relationships, and the unexpected. To negotiate this seems to take another type of mastery: the mastery of transition. Sometimes, after particularly long silent retreats, for example, the transition can be arduous and almost mitigate the benefits of the retreat itself.

The flow between meditation and life is in the very nature of active forms of meditation, thus making such transitions almost nonexistent. I have found that the enhanced awareness I bring to my daily activities allows me to be more sensitive to the needs of those around me and better able to balance my own energy throughout the day by finding rest amid activity.

One of the important goals of meditation is to become comfortable with yourself as you are in each moment. To extend this comfort into all moments is the next step, removing the need for transition. An enlightened person is able to do this, feeling comfortable everywhere and seeing the joy and beauty of each individual as a reflection from within. It is an active state and a permanent way of being.

The actual meditation practices simply teach techniques to develop concentration and one-pointedness so that the truth of your universal self can arise. The real shift takes place when this illuminating understanding can permeate all you do. In this state you are free of the illusion of your separateness. To go back to the analogy on the banks of the river, once you step back from the flow you see how you are a part of the whole geography. You see things as they are in truth, and in that moment you are free.

As the spiritual teacher Ram Dass often says, the goal of meditation is not to become a "meditator" but to become free. Hiding in a cave ensconced in contemplation might be a step toward this, but ultimately the cave of the heart has no walls and no restrictions. Solitude or crowds, silence or sound, city or nature, all is the same when seen through the lens of truth. Clarity of mind and happiness of spirit are the immediate results, side effects such as improved overall health, circulation, and energy levels may also be experienced.

Here is an old tale that exemplifies this principle of active meditation:

There was once a very wise king who had mastered the art of active meditation and performed his royal duties while maintaining complete inner awareness.

One day, a member of his court came to see him and asked, "How is it possible that you maintain such a meditative state while you are involved so outwardly with worldly affairs?"

The king replied, "I shall show you." With that, he reached for a goblet and filled it to the top with wine. As he gave it to his disciple, he said, "Walk through the palace. You will see many beautiful things—gemstones, works of art, beautiful women, delightful music, and sculptures—all finer than anything you have ever come across. Carry this goblet and stroll through the entire palace without spilling even a single drop. Then come and see me."

The eager student, who had studied meditation for quite some time, felt confident that he could concentrate on this. He thought, "I can do that. I just have to be extremely careful." And so he told himself firmly: "I am not going to pay attention to all the wondrous things around me. I will concentrate on this goblet alone. Nothing else will distract me." He fixed his gaze intently on the goblet and set out—walking very slowly. Carefully he made his way through the palace, and due to his meditation skills he was able to complete the task successfully.

When he came back to the king, he said, in an almost arrogant manner, "I've done it, I have walked throughout the palace and have not spilled a single drop of wine. Does this mean that I have mastered active meditation?"

With a smile, the king gently replied, "No, that is only the first step. Go back through the palace again. This time look at everything. Enjoy all of it! And remember: do not spill a single drop."

This beautiful story illustrates the importance of including inner and outer awareness in your meditation. Here you are in the world, and yet you have cultivated a deep awareness of your connection to the source. You can see the truth of your perceptions and experiences, elevating the mundane to the sublime.

7 Origins of the Sacred Yantra

After working with Yantras for a while, I took the time to trace some of the steps of the countless others who have trodden the path before me. I wondered, who were these seers that saw the original forms of the Yantras?

The Seers

Meditation was a way of life for one portion of society in the Middle Ages: these were the seers. Today we might call them philosophers or wise people. Through their meditations they were able to see through the veils of time and understand the nature of the universe in the past, present, and future. As such they were looked to for teachings and answers to many of society's questions. Through their visions, seers in ancient India saw and developed the original forms of the Yantras presented in this workbook. As part of the golden age in India, known as the Aryan civilization, the seers can be traced back to the Himalayas and the northern region of India around 2000 BCE. This was a noble civilization that greatly respected inner values, honesty, integrity,

and the quest for self-knowledge.* Society was kept in order by the seers. Though they were living on earth, they were deeply connected to the spiritual realms. They had the ability to perceive all dimensions of the cosmos. With one foot in each world, they could tune into the subtle realms through their meditation and convey cosmology to the people. These enlightened beings were rulers, influencing society to aspire to their level of wisdom. It was their role to lift up the consciousness of the people—through their insights and their ability to share information in an accessible way—integrating the spiritual with the every day.

One of the gifts that the seers shared was knowledge of numerous ways to align one's energy with that of the universe. This knowledge showed how a person's mind, body, and spirit reflected the outer movements of the cosmos and how one could better align himself with his divine purpose. It was the seers' connection to the source, the truth behind the illusory nature of all that changes, that allowed them to teach and reveal the truths of the universe. It was well into this period that the Yantras were revealed (around 1000 BCE onward).†

Three principal collections of knowledge convey the teachings of the seers. The first are the Vedas, which include the Upanishads and the Brahmanas. The second are the Puranas, a more devotional continuation of the Vedas. The third are the Tantras; these are contained in many books disseminating the practical teachings of the seers.‡ The Tantras teach an experiential form of spirituality.

The Tantras

Yantras are a part of this third collection known as the Tantras. The very word *tantra* means "to weave." The Tantras include teachings on Yantras, mantras, rituals, and worship and offer ways to weave spiritual practices into daily activities, bringing the spiritual into the ordinary as a weaver weaves the woof into the warp.

Tantric teaching is composed of three elements: the first is the tantra, or teaching itself; the second is the mantra, the sound vibration which is connected to a deity or planetary energy, directly bringing us into contact with the divine force; and the third is the Yantra, the visual form through which the deity, planetary energy, tantra, and

*David Frawley, *Wisdom of the Ancient Seers* (Salt Lake City, Utah: Passage Press, 1992).
†Author interview with Dr. Robert E. Svoboda, February 2004.
‡David Frawley, *From the River of Heaven* (Salt Lake City, Utah: Passage Press, 1990).

mantra can all be realized. The Yantra is therefore a powerful symbol through which the teachings can be conveyed.

To bring harmony to individuals who had become disconnected from the universal truths, the seers accessed energy patterns that have the power to reestablish the connection between the individual and the universe. They heard these patterns as sound vibrations, which are pronounced as mantras. These mantras, or sounds, can lead us back to the source of the sound, to that peaceful place within. Through their connection to these sounds, the seers visualized the Yantras that are generated by them. A very specific visual pattern in space is actually created by, and correlates precisely with, each sound frequency. By meditating upon the Yantra and hearing or reciting the associated mantra, one can rediscover a profound connection to the source. If the universe is imagined purely as matter, defined in quantum physics as energy moving at a certain rate of vibration, these practices will make more sense. The healing practices revealed in the Tantras use vibration as the medium. Yantras and mantras, color and sound, are all vibration. We as individuals are also vibration, just as the entire universe is vibration. Using this knowledge as a starting point allows you to connect with the source as a means to self-healing. Disturbances in our energy field—or vibrational pattern—are what cause us to feel disconnected, fragmented, or dis-eased. These tantric practices are intended to tune us into the source of all vibration and to allow us to feel whole and complete again.

The Yantra

The geometric forms within this book are known as Yantras; however, when we look at its Sanskrit origins, the word *yantra* itself has two distinct meanings. It comes from the root *yam,* which means supporting or holding the essence of an object or concept. The syllable *tra* comes from *trana* or liberation from bondage. Thus *yantra* also means "liberation" *(moksha)* from the cycle of birth and rebirth. Yantra meditation is used to withdraw consciousness from the outer world, so as to help the individual go beyond the normal framework of mind to the altered states of consciousness known as *turiya.*

The center of the Yantra, the bindu, represents the eternal oneness found in all things, while the background of the Yantra conveys a specific vibration of this universal energy. The gods and the planets are the main subjects for the Yantras. Understanding the Yantras as containers for spiritual energy, the seers found a way to embody within them the celestial forces they saw in the universe. Thus, we can experience the Divine through worship and meditation of this tangible form.

When used for visualization and meditation, Yantras can redirect our energy in a creative and transformative way. I have often experienced surges of energy as a result of creating a specific Yantra. I remember feeling particularly scattered and aimless one day, wondering how I could "construct" a future for myself with these ancient spiritual practices that I am so passionate about. When I finally sat down to draw the Yantra that I thought would provide some clarity for me, the process itself brought me to a one-pointed focus. The beauty of the construction and the application of color made me feel part of something universal, as if I were an instrument in divine hands. The part of "me" that had been worried and fragmented dissipated, and I felt comfortable resting in the practice. From this place of rest it seemed obvious that there was great direction in the work I was doing, and I was able to move on with my day with a sense of both joy and ease. It is so interesting how taking "time out" to do a spiritual practice can actually bring you more fully "in" to your life. I've often marveled at how the process of surrendering to the powers of such a practice brings forth an immense sense of guidance.

Yantras can be used in meditation either as purely geometric centering devices or as symbolic compositions of the energy pattern of a deity as envisioned by the tantric seers. When a Yantra is adopted for meditation and its energy is invoked, it becomes a symbolic representative of the deity. When the person abandons his analytical, critical attitude and the energy circulates in higher centers, the Yantra actually becomes the deity. Every Yantra becomes the dwelling place of the deity it represents.

The Mantra

The mantra is the audible sound associated with the Yantra. Today the word has become popularized and is used as a catchphrase. This has resulted in a slight distortion of its original meaning, leaving out the motivation for spiritual growth and purification. Habitual repetition of a personal mantra can be very effective if its intention is to elevate the consciousness of the individual so that he or she may know a deeper place of peace and happiness within.

The Sanskrit word *mantra* comes from the root *manas,* which signifies the mind, and *tra,* which as with *yantra* means the liberation from—literally transcending or traversing, going beyond or crossing over—the fluctuations of the mind. By repeating the sacred sound, or *mantra,* one can cut through the "mind stuff" and rest in the deeper states of awareness and joy.

Practitioners of tantra combine the universal pattern of the Yantra with the cosmic sound of a mantra to achieve a higher state of awareness, in which individual being and universal being are one.

8 Enhancing Your Yantra Power

Once the creative process is underway it may inspire you to make many Yantras. It is as much a joy to make all nine of them as it is to make the same one over and over again, delving deeper into the nuances of its beauty. The subtle variations in color, shapes, and lines engage the mind and senses and penetrate the spirit as you become more absorbed. I feel I never actually make the same one twice. Meditation during the creation of the Yantra is a miraculous process and one that necessitates your full participation. As your faculties for assimilating the benefits of the colored forms sharpen and the Yantras begin to pile up, you may wonder what to do with them all.

To complete the process I find it helpful to keep the designs out in my living space for some time. This allows me to get better acquainted with their energy and to form an intimate relationship with them. As with all relationships, this takes time. There are periods when I intensely dislike one of the forms, and then months later it is my favorite Yantra and I am compelled to enjoy several minutes in front of it each day. There is a delight in seeing; in using the sense of sight to awaken an inner joy on a daily basis. Knowing all the facets of your personality, including perhaps previously hidden aspects of yourself, is important in the journey to whole-

ness. This is mirrored as you embrace the full spectrum of colors within the Nine Designs, each color resonating with a particular part of you, letting you relax into the fullness of your being.

Where Should I Put My Yantra?

If you have chosen to create one of the designs with the intention of helping you with a certain area of your life, then you can place the finished design in the room associated with that area. For example, a Yantra chosen to enhance your career would be well placed in your office or over your desk. One made with the intention of attracting romance could be placed in the bedroom—or by the phone!

There are also specific directions that are optimum for the designs' placement, which you might like to consider. This is connected to the planetary associations of each design. Each planet has a directional correlation and when you place the design in this location you are adding to its natural life-giving forces. Below is a list of the Nine Designs along with the associated planet and direction for each. Place the Yantra on the wall of the specified direction. The Radiance Design, for example, will be placed on the east wall.

Radiance (Sun): East

Nourishment (Moon): Northwest

Passion (Mars): South

Intellect (Mercury): North

Expansion (Jupiter): Northeast

Bliss (Venus): Southeast

Organization (Saturn): West

Uniqueness (Rahu): Southwest

Spirituality (Ketu): Southwest

Framing the designs is the preferred way of protecting them and honoring their power. Square frames can reinforce the shape of the bhupur in a positive way. It seems to me that the Yantras are happiest when on display, rather than stacked up in a corner out of sight. You can also give the designs as gifts to friends who would benefit from their uplifting energy in the home or workspace.

On What Day Should I Wear Red?

Another way to bring the magic of the Nine Designs into your daily life is to correlate the colors and sentiment of the design with the day of the week. Each of the designs is influenced by the planetary energy according to the days of the week. You might choose to actually prepare the chosen design on its specific day when that energy is going to be the strongest, or you can enhance the rhythm of your own week by focusing on the qualities and colors of that day's design. Each design and its correlating day of the week is listed below:

Radiance (Sun): Sunday

Nourishment (Moon): Monday

Passion (Mars): Tuesday

Intellect (Mercury): Wednesday

Expansion (Jupiter): Thursday

Bliss (Venus): Friday

Organization (Saturn): Saturday

Uniqueness (Rahu): Saturday*

Spirituality (Ketu): Tuesday*

I have gradually developed an awareness of this weekly cycle, recognizing the nine qualities as they express themselves during the week. For example, on Tuesdays, associated with the Passion (Mars) Design, there is a great movement to accomplish things, to be goal oriented and passionate about one's endeavors. I have noticed that wearing red can help me align myself with these feelings. Saturdays, by contrast, feel more inward and practical. The day is ideal for domestic tasks and organizing the home, and black or dark blue clothing might be more appropriate.

Of course none of this is set in stone, but you might like to see if any of this rhythm pertains to you. You don't need to dress in the chosen color from head to toe. Bringing the vibration of the specified color to your day can be as simple as wearing an undershirt or carrying a handkerchief of that color. Maybe only one of the days has a striking effect upon you. Perhaps you like to study on Wednesdays or take a

*While the Uniqueness Design (Rahu) and Spirituality (Ketu) also correspond to days of the week, their influence is felt on a more subtle level. Therefore, for Saturday and Tuesday the primary correspondences are Organization (Saturn) and Passion (Mars).

walk in nature, spending some time "in the green" on that day. The responses to these influences will be highly individual and there is no right or wrong reaction to them. Regardless, your interaction with your environment will be affected positively with this deeper awareness that you are cultivating in daily life.

The intense "coloring" of the phases of your days, weeks, months, and years will be a result of the active meditation you practice with the Yantras. Knowing yourself more fully according to these cycles and rhythms is the first step to feeling in tune with the universe. Touching the universal place of peace within is the fruit of this meditation; having beautiful Yantras to adorn your living space is a bonus!

APPENDIX
Outlines of the Nine Designs

Coloring the forms within the Yantra awakens the power of the design. The coloring process is also a powerful form of meditation that leads you to a deep appreciation of the sacred Yantra. Outlines of each of the Nine Designs are provided here. This is a great option for those who might not want to begin with drawing the Yantra from scratch.

You can photocopy the outline for your chosen design. Depending on the thickness of the copy paper, you can use colored pencils, crayons, or paints to color the design. The thinner paper will be appropriate for colored pencils and crayons. Paint requires thicker paper. If your paper is too thick to use in the photocopy machine, you can trace the outlines onto the thicker paper suitable for painting.

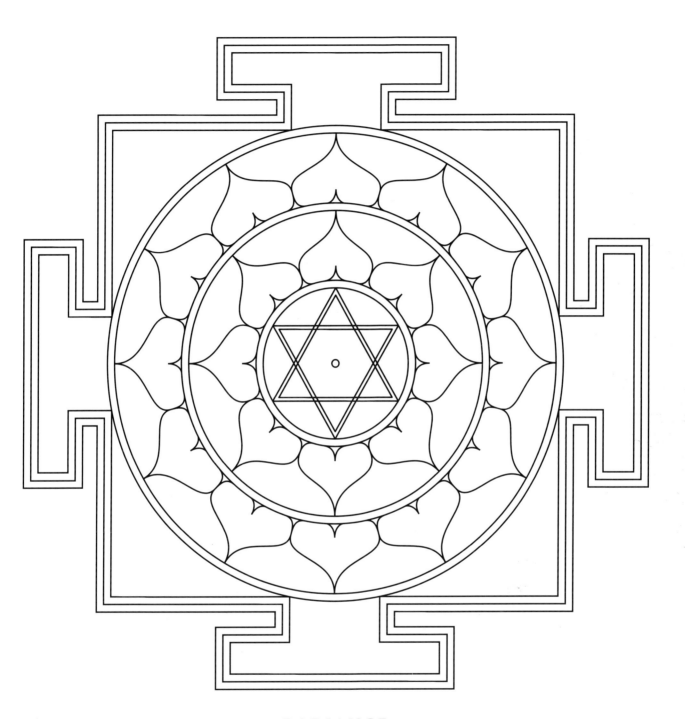

RADIANCE

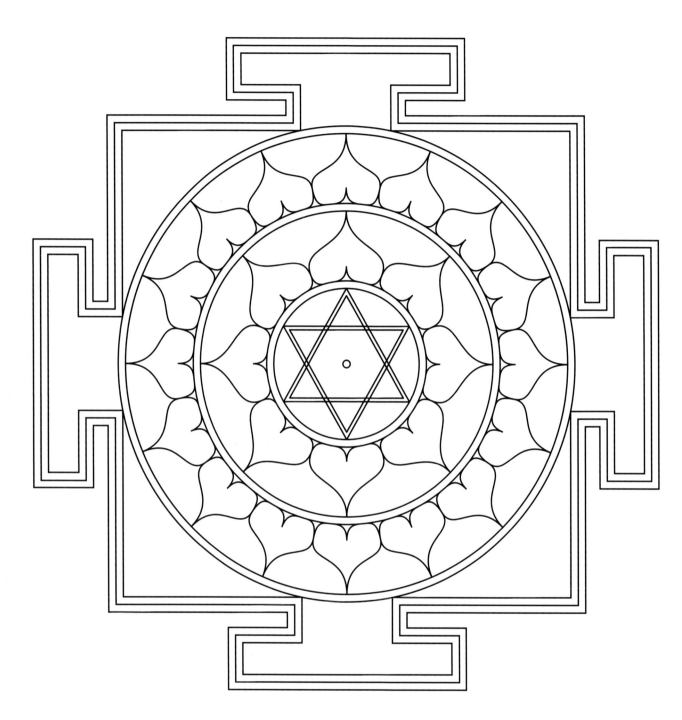

NOURISHMENT

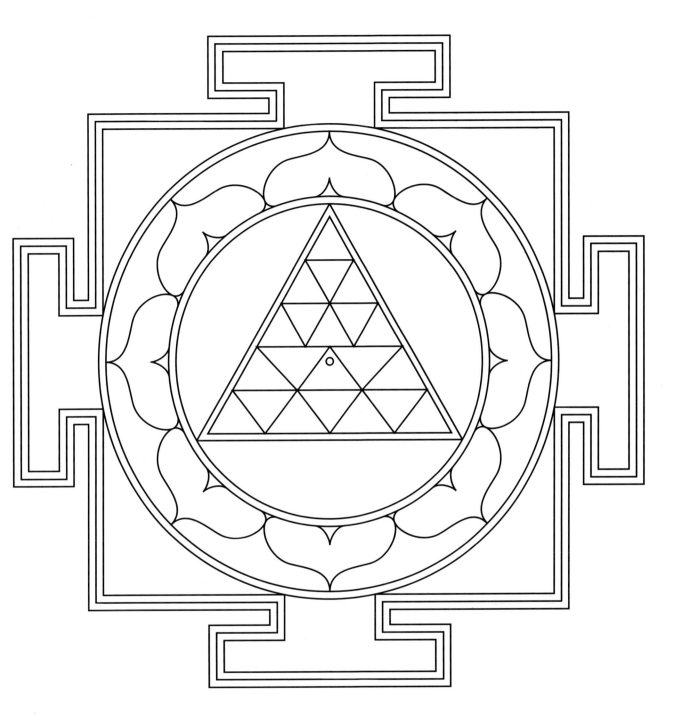

PASSION

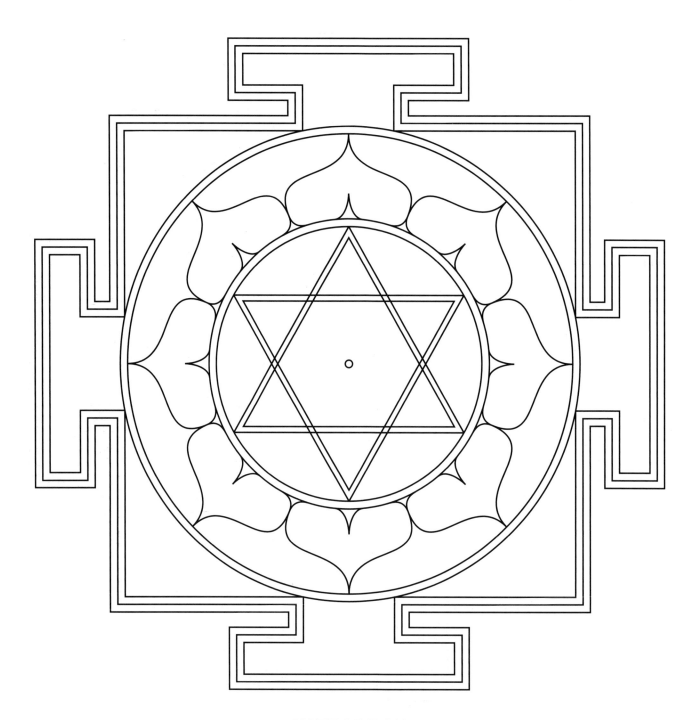

INTELLECT

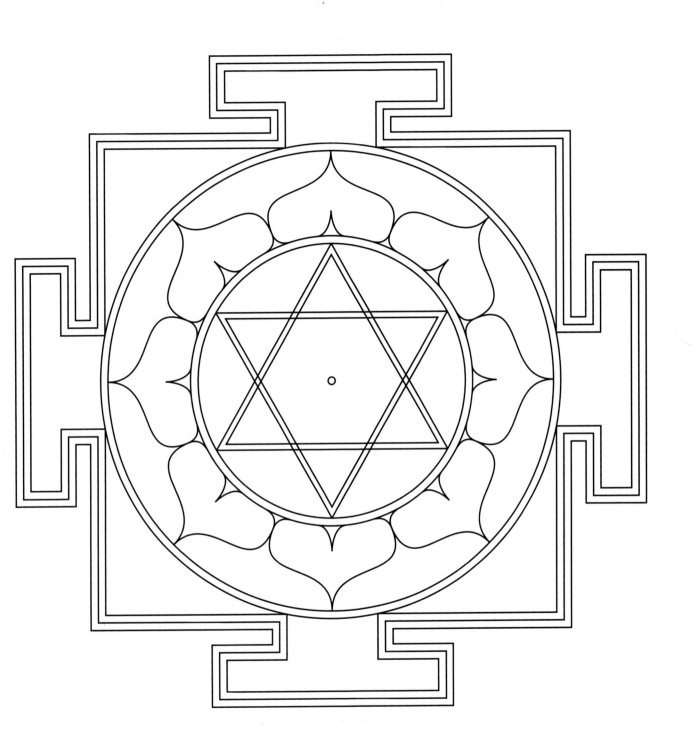

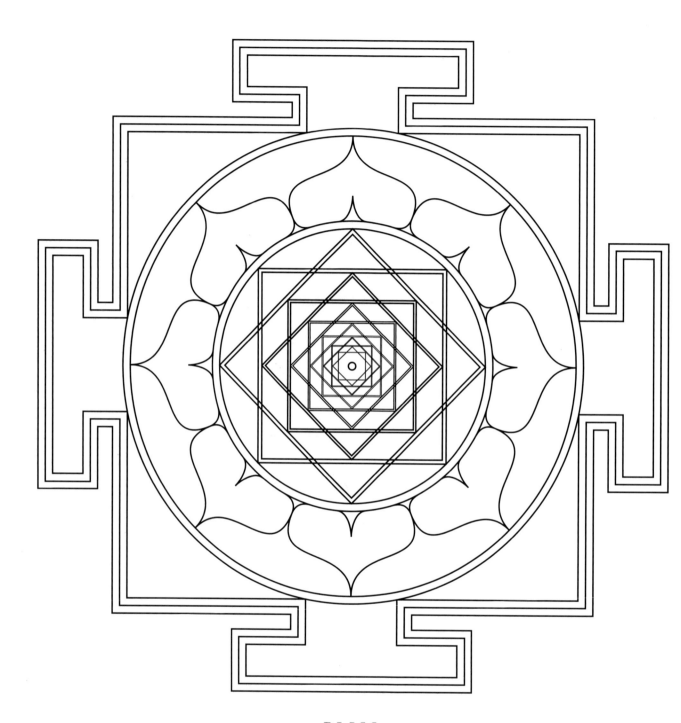

BLISS

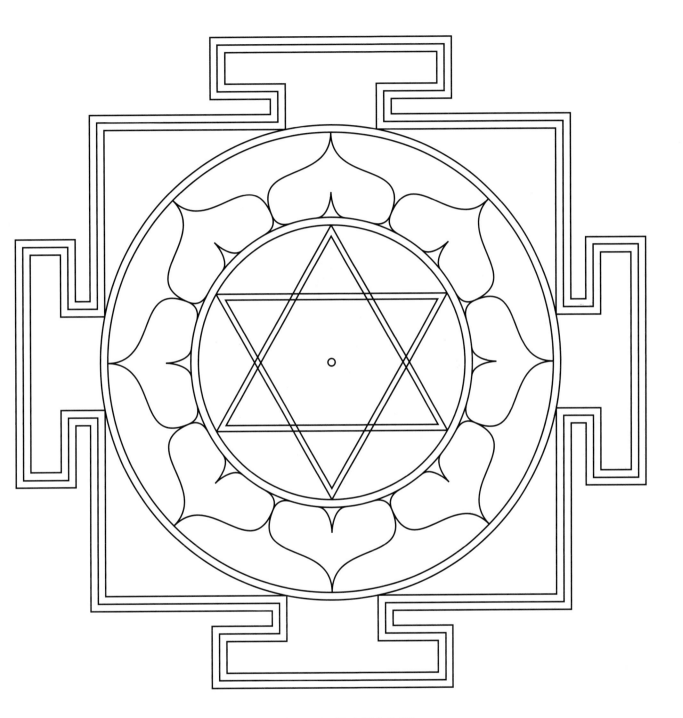

ORGANIZATION

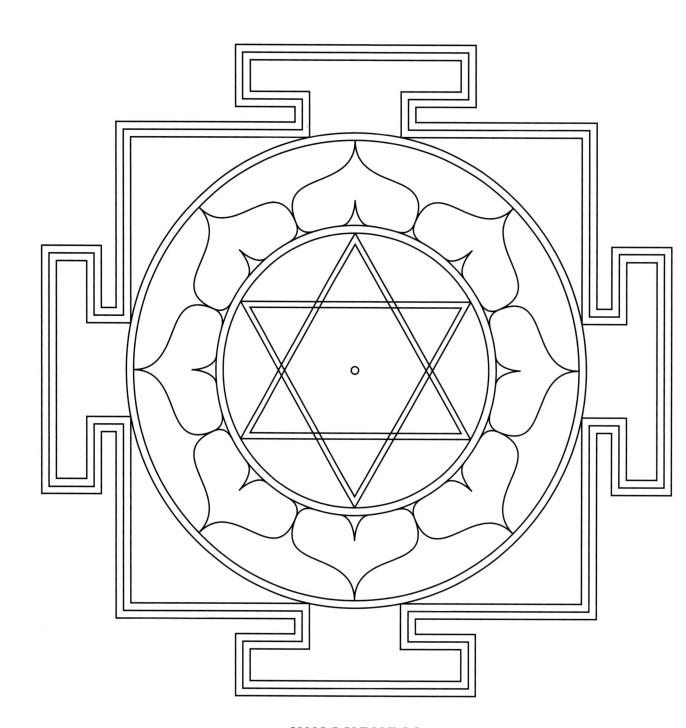

UNIQUENESS

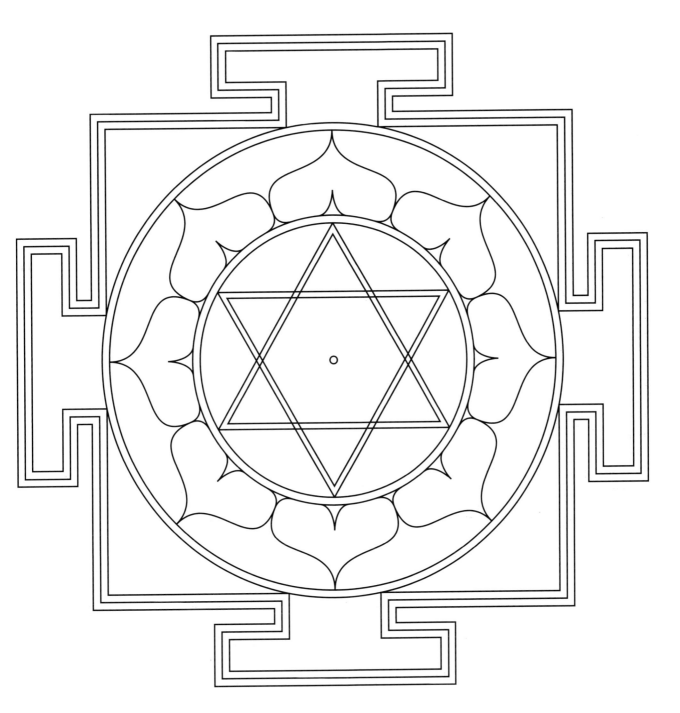

SPIRITUALITY

Resources

Yantra Workshops and Retreats

Sarah Tomlinson leads Yantra painting workshops and retreats worldwide including an annual Yantra and Yoga Retreat to Harish Johari's family home in Haridwar, India. For more information, visit www.yantratecture.com.

Planetary Mantra CD

Beautiful recording of the planetary mantras by Gandharva Sauls. Each track contains one of the nine mantras used in this workbook. For ordering information, go to www.ayurvedayogainstitute.com.

Ancient Ayurveda Blueprint

The Nine Planets are configured in a unique way in your personal Ancient Ayurveda blueprint. To find out which planet governs your spiritual path, career, relationships, physical health, desires, creative play, stress reduction, dharma, and emotions go to www.ayurvedayogainstitute.com for information on scheduling a consultation with Gandharva Sauls. Consultations are available in person, by phone, or on CD.

To read more about Edward Tarabilda and the origins of Ancient Ayurveda, also visit www.newu.org.

Harish Johari

To read more about Harish Johari's life and work, visit www.sanatansociety.com.

For books by Harish as well as other titles based on his teachings, go to www.innertraditions.com.

Bibliography

Beckman, Howard. *Mantras, Yantras and Fabulous Gems.* Pecos, N. Mex.: Balaji Publishing Co., 1997.

Defouw, Hart, and Robert Svoboda. *Light on Life.* New Delhi: Penguin Books, 1996.

Frawley, David. *Astrology of the Seers.* Delhi: Motilal Banarsidass Publishers, Private Ltd., 1992.

———. *From the River of Heaven.* Salt Lake City, Utah: Passage Press, 1990.

———. *Wisdom of the Ancient Seers.* Salt Lake City, Utah: Passage Press, 1992.

Johari, Harish. *The Healing Power of Gemstones.* Rochester, Vt.: Destiny Books, 1988.

———. *Numerology.* Rochester, Vt.: Destiny Books, 1990.

———. *The Planet Meditation Kit.* Rochester, Vt.: Destiny Books, 1999.

———. *Tools for Tantra.* Rochester, Vt.: Destiny Books, 1986.

Sutton, Komilla. *The Essentials of Vedic Astrology.* Bournemouth, UK: The Wessex Astrologer, 1999.

———. *The Lunar Nodes.* Bournemouth, UK: The Wessex Astrologer, 2001.

Tarabilda, Edward, and Douglas Grimes. *The Global Oracle.* Fairfield, Iowa: Sunstar Publishing, 1997.

Index

Page numbers in *italic* indicate illustrations.

success, 109
Svoboda, Robert E., 32n, 153n

tai chi, 121
Tantras, 153
tantra (to weave), 153
Tarbilda, Edward, 170
teaching, 109
thousand-petaled lotus, 47
Tibetan Buddhists, 149
Tomlinson, Sarah, 170
Tools for Tantra (Johari), 2
tranquillity, 103, 135
transcendence, 146
transitions, 149
triangles, 29, *30*
 design notes, 62
 downward-pointing triangles, 61
 inner triangles, instructions, 65–68
 upward-pointing triangle, 61, 97
 upward-pointing triangle, instructions,
 63–64
trinities, 61
trust, 10, 123
turiya (altered states of consciousness),
 154
twelve, the number, 47

Uniqueness Design
 gemstone, 127
 images, *126, 128*
 mantra for, 126, 129, 130
 outline of, 168
 qualities of, 6, 127
 recipe for, 130–31

universal self, 150
Upanishads, 153

Vedas, 153
vibrational patterns, 154
voice, finding one's own, 127, 129
void, the, 80

wax crayons, 25
website addresses, 170
willpower, 99
will to succeed, 97
wisdom, 91, 109, 117, 123, 133, 135, 146
Wisdom of the Ancient Seers (Frawley), 153n
Wise Woman tradition, 45
workshops and retreats, 170
workspace, 23–24

Yantras
 about, 5–7
 design placement in living environment, 157
 meaning of, 154
 meditation with, 155
 movement and, 31, 32
 origins of, 152
 placement of shapes and, 29
 proportional measurements and, 33
 repetition and, 17
 universal patterns of, 11
yoga, 2, 11, 47, 69, 121
yogis, 149
youthfulness, 103

Zen Buddhism, 61
zero point, 80